SEFTON IN 50 BUILDINGS

HUGH HOLLINGHURST

AMBERLEY

First published 2017

Amberley Publishing, The Hill, Stroud
Gloucestershire GL5 4EP

www.amberley-books.com

British Library Cataloguing in Publication Data.
A catalogue record for this book is available from the British Library.

ISBN 978 1 4456 6266 4 (print)
ISBN 978 1 4456 6267 1 (ebook)

Origination by Amberley Publishing.
Printed in Great Britain.

Contents

Pier, Southport (1860).

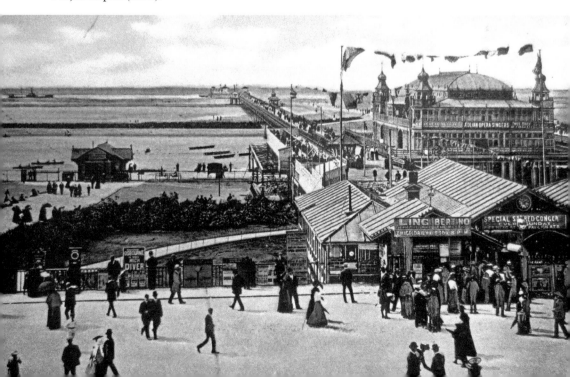

Acknowledgements

To the Historic Society of Lancashire and Cheshire for their generous donation towards the maps and archive photos.

To Paul Hollinghurst for the production of the maps.

To the following for illustrations (references are to chapter and image sequence): Mark Blundell for 2.2, 2.3, 6.2 and to him, Paul Barker and Country Life for 6.1, 6.3, 8.2; Ron Cowell and National Museums, Liverpool 1.1; Edward Creighton 1.3; Crosby and District Historical Society archive 10,2; Albert Haworth© 35.1; *Liverpool Echo* 48.1; Merchant Taylors' School for Boys Archive; Roger Hull 49.3; Liverpool Record Office 27.1, 48.2; Peter Owen 16,1, 17.1, 17.3, 19.2, 44.2, 50.1; Martin Perry (in addition to his many insights on Southport) page 3, 5.2, 9.2, 13.2, 18.2, 20.2, 20.3, 21.1, 21.2, 23.1, 28.1, 29,1, 29,2; 30.2, 33,3, 34.1, 36.3, 40.2, 41.1, 41.2, 42.2; Sefton Library Service 12.2, 14.2, 15.3, 33.2, 46.2, 49.2; Bob Truman 44, 1; Pam Whelan 4.1, 4.2; *Yorke & Yorke, Britain's First Lifeboat Station*, The Alt Press, 1982, p52, 47.2.

All others taken by the author or from his own collection.

Above all, to my wife Joan for her encouragement, patience and understanding.

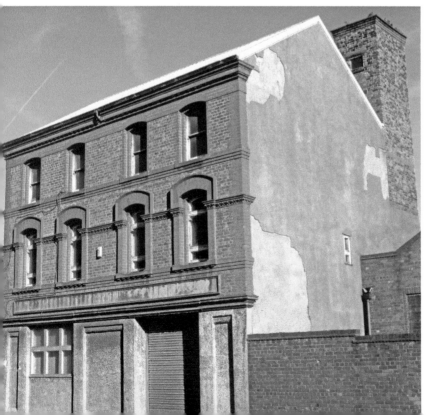

Bootle Fire Station (1887).

Introduction

Created in 1973 by the reorganisation of local government, Sefton is one of the most variegated boroughs in the land. It encompasses three former boroughs: the genteel seaside resort of Southport (1866) at one end, industrial seaport Bootle (1869) at the other end and residential Crosby (1937) in the middle. There are also the old villages of Formby on the coast and inland Maghull. Along the stretches of beautiful coastline, Sefton is home to six golf links courses including championship Birkdale. The rural hinterland is the setting for grand country houses and for the tiny village of Sefton, which gives its name to the borough. Like many of the villages and townships, it is mentioned in the Domesday Book.

St Helen's, the church of Sefton village, built from the fourteenth to sixteenth centuries, is the only Grade I-listed building in the borough. Its Gothic Early English and Perpendicular style anticipates many other Gothic Revival churches built in the area during the nineteenth and twentieth centuries. Crosby Hall (early seventeenth century) is complemented by Little Crosby village, preserved with cottages as built from 1669 to the Edwardian era. The oldest building of the Merchant Taylors' Schools in Crosby dates from 1620. In Bootle, Lord Derby's hunting lodge of 1773 and the Victorian complex of Bootle's civic buildings miraculously survived the blitz. Its few surviving industrial and residential buildings of the era contrast with modern post-war commercial redevelopment. Southport sports the second longest pier in the country and many distinguished classical buildings adorn the length and breadth of Lord Street. A hotel and Victorian folly in Waterloo remind us visibly of the battle and nearby stand the homes of the chairman of the White Star Line and captain of the *Titanic*. Seaforth has seen the construction of the Royal Container Dock in 1973 and its extension also 'Liverpool2', a new deep-water terminal capable of receiving Post-Panamax container ships. This, and Bootle's £100 million development plan, brings the borough into a new age.

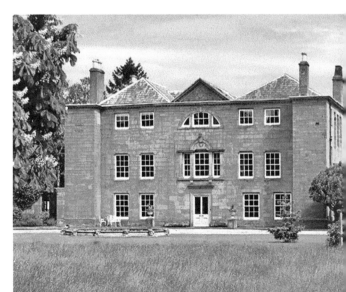

Crosby Hall (1609).

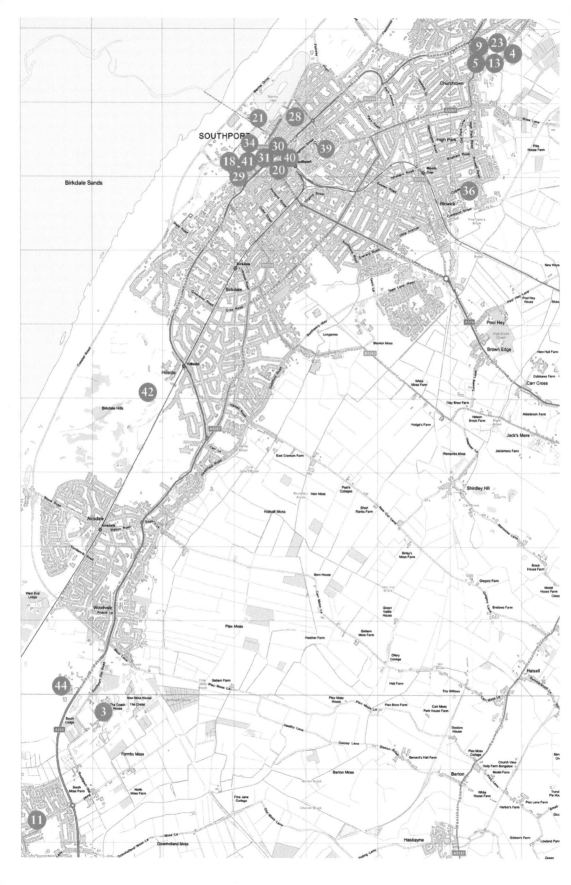

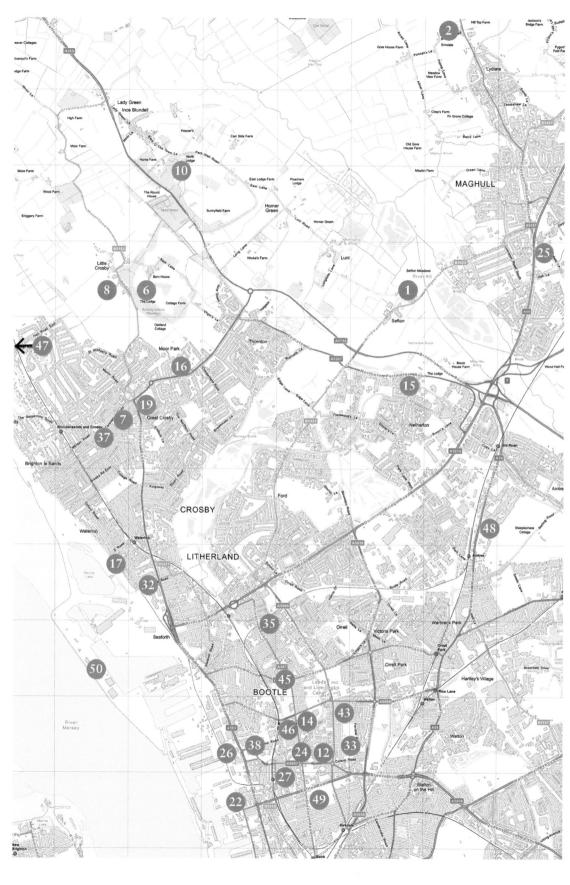

Key

1. St Helen's Church, Sefton
2. The Scotch Piper Inn, Lydiate
3. Formby Hall
4. Meols Hall, Churchtown
5. Thatched Cottage, Churchtown
6. Crosby Hall
7. Merchant Taylors' School for Girls Library, Crosby
8. Ned Howard's Cottage (The Priest's House), Little Crosby
9. St Cuthbert's Church, Churchtown
10. Ince Blundell Hall
11. St Peter's Church, Formby
12. Old Hall, Bootle
13. Hesketh Arms, Churchtown
14. Leeds Liverpool Canal Bridge, Bootle
15. St Benet's Chapel, Netherton
16. Windmill, Crosby
17. Royal Hotel, Waterloo
18. Royal Clifton Hotel, Southport
19. St Luke's Church, Crosby
20. Town Hall, Southport
21. The Pier, Southport
22. Borough Hospital, Bootle
23. Botanic Gardens, Southport
24. Abigail Rest Home, Bootle
25. St Andrew's Church, Maghull
26. Harland and Wolff's Foundry, Bootle
27. Town Hall, Bootle
28. Promenade Hospital, Southport
29. Lord Street Station, Southport
30. Albany Buildings, Southport
31. Midland Bank, Southport
32. Christ Church, Waterloo
33. Derby Park Bandstand, Bootle
34. Wayfarers Arcade, Southport
35. Linacre Mission, Litherland
36. Tramway Depot, Blowick, Southport
37. Carnegie Library, Crosby
38. Fire Stations, Bootle
39. Holy Trinity Church, Southport
40. The Monument, Southport
41. Garrick Theatre, Southport
42. Royal Birkdale Golf Club
43. St Monica's Church, Bootle
44. Woodvale Airfield
45. Johnsons Cleaners, Bootle
46. The Triad, Bootle
47. Coastguard Station, Crosby
48. Aintree Race Course
49. Hugh Baird College, Bootle
50. Seaforth Container Dock Cranes

The 50 Buildings

When the new Metropolitan Borough of Sefton was created in 1974, the constituent boroughs agreed on the name of a central, tiny and, above all, neutral village in the countryside. St Helen's Church is the oldest and only Grade I-listed building in the district (Grade I-listed buildings comprise only 2.5 per cent of all those listed in the country). Most of it dates from the fifteenth and sixteenth centuries but the tower and spire are from the 1300s and there are stone fragments indicating a small chapel of the late twelfth century. The church, built mainly in the late Perpendicular style, has been called 'Cathedral of the Fields' or the 'Jewel of south-west Lancashire', although criticism has been expressed of the heavy 'beehive' pinnacles supporting the steeple. After the Reformation it became an Anglican Church and was the parish church for the whole area until 1853 when the daughter parish of St Luke's, Great Crosby, was formed. Other parishes were carved out of it so that St Helen's is now the mother and grandmother of twenty-nine local churches.

The woodcarving is outstanding: the early sixteenth-century carved pew ends, the seventeenth-century canopied pulpit and the late Gothic tracery (on the screens to north, south and west of the chancel, and alongside the chapels and Lord Sefton's pew).

The Molyneux family from Sefton and Croxteth were patrons of the church and many were rectors before the Reformation. By the mid-nineteenth century it was the second richest parish in the country and the living was sometimes held by absentee rectors with curates taking the services. The social life was enhanced by a mock corporation, which met during the second half of the eighteenth century. The monuments comprise the best series in Lancashire. Sir William Molyneux fought at the Battle of Flodden and there is a picture in brass on the floor of the south aisle showing him in the armour he probably wore at the battle. Others buried here are the Blundells of Crosby and Ince Blundell, and John Sadler, who discovered the secrets of transfer printing on pottery.

The oldest remains of any building in the borough date from the Mesolithic period around 6,000 BC. The remains are seen here being excavated near Lunt only one and a half miles from Sefton Church.

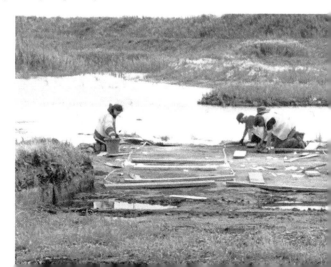

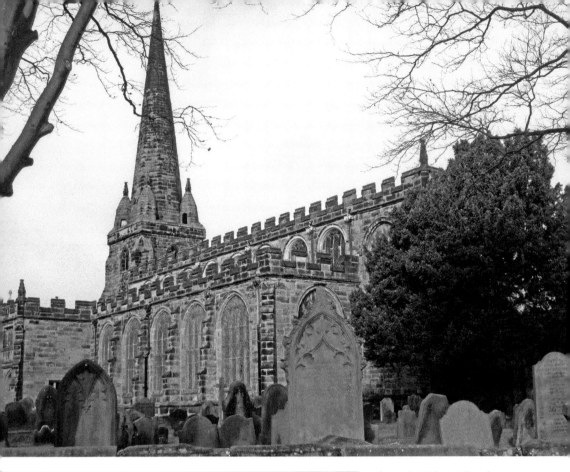

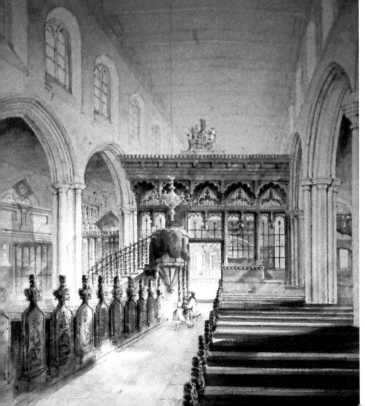

Above: St Helen's Church,
Sefton.

Left: Interior of Sefton Church
in 1890.

2. The Scotch Piper Inn, Lydiate

The Scotch Piper Inn, Lydiate, proclaims itself as the oldest pub in the historic county of Lancaster, dating from 1320. However, its Grade II* listing by English Heritage dates it 'probably from around the 16th century' (only 5.5 per cent of listed buildings are in the Grade II* category, defined as being 'particularly important' and 'of more than special interest'). It certainly has at least two cruck frame trusses and a wattle chimney hood on the first floor (a cruck frame is a large pair of curved timbers rising from the ground level to the apex of the roof and acting as principal supports). It was originally known as 'The Royal Oak', and sections of the trunk of the oak tree around which it was built are visible from the tap room.

The inn is part of a conservation area that includes the nearby remains of Lydiate Hall and St Katherine's Chapel, known locally as Lydiate Abbey. Lydiate Hall was built in the sixteenth century by Lawrence Ireland. The family held the Lydiate lordship from 1410–1673. It was a known Catholic house during the time of Elizabeth I of England, and the building contained at least three priest holes. It was altered in the nineteenth century, but after repairs in 1907 it fell into decay and is now part of the grounds of Lydiate Hall Farm. However, the ruined site has been restored and you can still trace the remains of the great hall, fireplace, courtyard with gatehouse, screens passage, the north wing (rebuilt in Victorian times) and the chimney with stone robbed from the chapel.

The abbey was built around 1500 for the private worship of the Ireland family and was named after Katherine, Lawrence Ireland's wife, daughter of Henry Blundell (II) of Crosby. Its use as a private chapel probably ceased around 1550, following Henry VIII's Dissolution of the Monasteries, though a small cemetery on the same grounds was still in use until the latter part of the nineteenth century. It is Grade II* listed and used to be one of the only two surviving private chapels in Lancashire.

The Scotch Piper Inn, Lydiate.

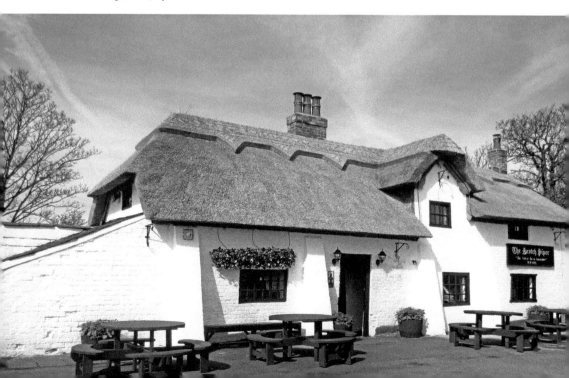

Above: Lydiate Hall in the 1860s.

Below: Lydiate Abbey in the 1860s.

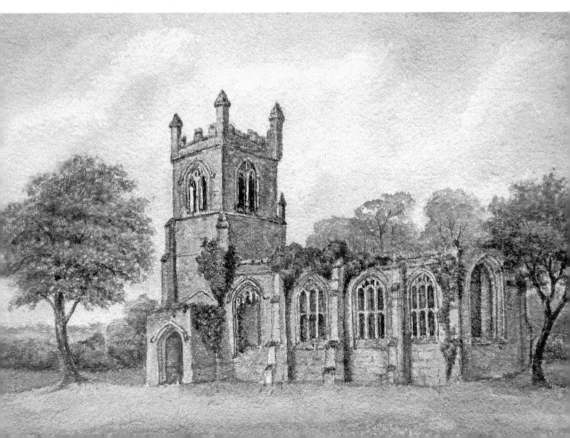

3. Formby Hall

The Formbys occupied the site of Formby Hall from at least the thirteenth century. The present house was built for William Formby in 1523. John Formby, impressed by the architecture of Horace Walpole's house at Strawberry Hill, London, added the battlements in the eighteenth century. Colonel John Formby modernised the house in 1896 and added the west wing drawing room. In 1958 the last lord of the manor, Colonel John Frederic Lonsdale Formby, died. As his sons had both died in the Second World War, the estate passed to a nephew living in Australia and fell into disrepair. In the 1970s John Moores Jr leased the hall, using it as a rest home for children from crowded areas of inner city Liverpool, but by the 1980s, disused and derelict, it was sold off along with the estate. The hall has been restored to its former glory and is now a private residence.

One notable member of the family was Richard Formby, armour-bearer to Henry IV, who fought at the Battle of Shrewsbury in 1403. Although he was buried in York Minster behind the altar, the original gravestone now lies in the porch of St Luke's Church. Otherwise the family did not seek honours or titles and were content to look after their estate. Like most landowning families in west Lancashire, they remained Roman Catholic after the Reformation but they did not take part in the Civil War or Jacobite Rebellions and became Protestant in the 1720s. Revd Richard Formby (1760–1832) was not only squire but also parson of St Luke's.

The hall and its well-preserved dovecot are both Grade II* listed. The dovecote is square, unusually, and has a pole in the middle with steps cut into it so that someone feeding the

Formby Hall.

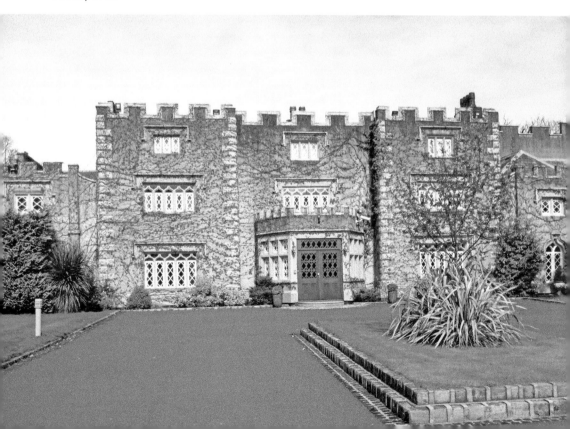

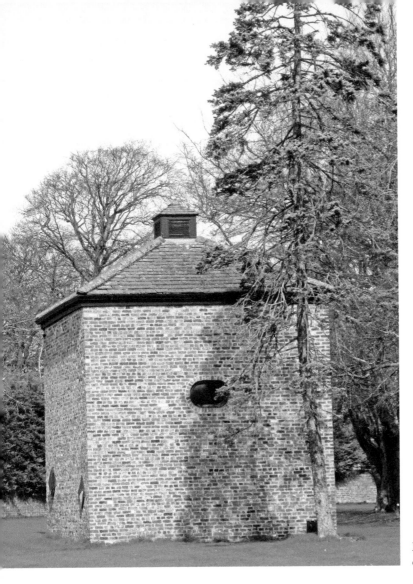

Formby Hall
dovecote.

pigeons could more easily reach the nesting holes. After the Norman Conquest dovecotes became widespread but now this is the only one in the area. Pigeons mate for life and are prolific breeders (two chicks a year for seven years) so dovecotes used to be an important source for meat during the winter months and for a quick meal when visitors arrived. Valuable by-products were feathers and manure.

4. Meols Hall, Churchtown

Meols Hall is the seat of the Hesketh family. Together with the Bold family, they were the lords of the manor who created Southport in the nineteenth century. The Heskeths' other family homes at Rossall and Heysham had given them experience of sea bathing. Sir Peter Fleetwood Hesketh was instrumental in the construction of a sea wall and promenade at Southport, starting in 1835. However, he was nearly bankrupted by founding

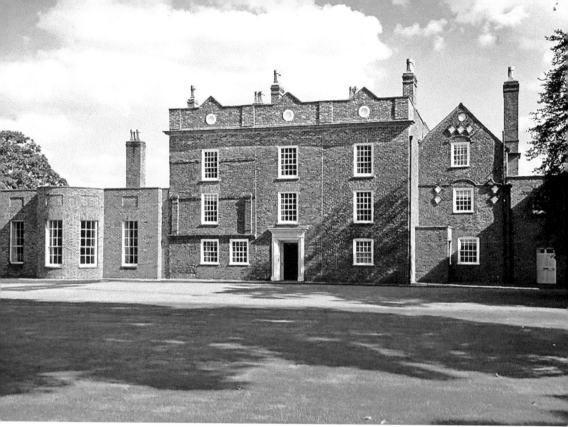

Above: Meols Hall.

Right: The 400-year-old Tithe Barn.

and developing the town of Fleetwood and was forced to sell the hall to his younger brother, Revd Charles Hesketh, who became rector of St Cuthbert's Church. His father had given the land for Christ Church and he himself gave the land for Trinity Church, both in Southport.

Meols Hall has stood on this site since the early reign of King John and passed through twenty-seven generations to the present owner. The main three gabled building dates from the middle of the sixteenth century. An extension to the south was added in 1695 and extended further by the south wing and library to the north, both completed in 1964. These enabled the display of family portraits by Romney, Raeburn, Lawrence and Wright of Derby, and paintings by Jan Brueghel the elder and Poussin.

The Heskeths of North Meols remained Catholics throughout the seventeenth and early eighteenth centuries, and were imprisoned periodically as recusants (that is for refusing to attend Protestant services). There are still the remains of a priest's hiding place where, according to legend, Sir Edmund Campion hid on his last visit to Lancashire before being executed. During the First World War the house was used as a hospital for wounded Belgian soldiers. Colonel Roger Hesketh, MP for Southport from 1952 to 1959, masterminded Operation Fortitude in the Second World War and designed the twentieth-century alterations to the house.

5. Thatched Cottage, Churchtown

Churchtown sports twenty thatched cottages, more than any other district in Sefton, but many others survive in Marshside, Southport itself, Birkdale and Formby. The prevalence of thatch was due to its readier availability in the grasslands of west Lancashire compared with the distant supplies of stone or slate. Many have cruck or 'A' frames with wattle and daub. Most face south or south-east to catch the sun. Thatched cottages in Windsor Road and Gores Lane, Formby, date from the early seventeenth century.

The cottage photographed recently is unusual for Southport in that the main part is two storeys (with a single-storey offshoot). Its location close to St Cuthbert's Church and fronting the Churchtown village green suggests it was higher status than most in the area.

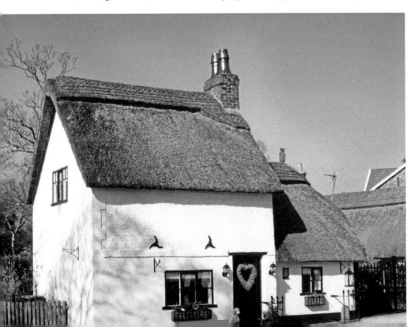

Thatched cottage in Churchtown.

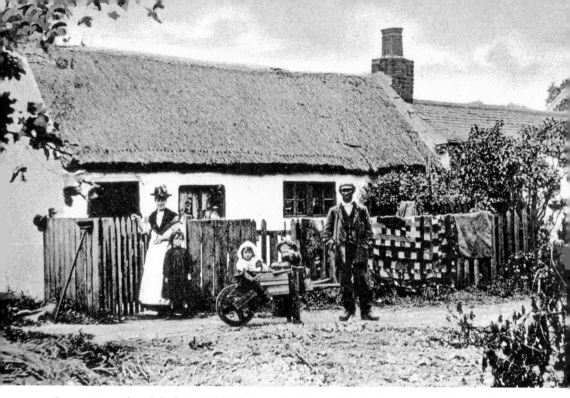

Cottage (now demolished) in Old Park Lane, Southport. The family are dressed up for the occasion, particularly the lady with her hat. The cottage next door has a tiled roof.

However, like them all, it was built of whatever material could be found on a windswept coast, mainly what could be picked up on the beach. Hence ship's spars are used as purlins but also bog oak was found when it was rethatched. Attached to the cottage is a gravestone 'In memory of Joey died Oct 16 1941, aged 16 years. A good & faithful dog'.

Walls in the area were traditionally timber framed and finished with wattle and daub (in North Meols, clamstaff and daub, a mixture of clay reinforced with straw and star grass from the dunes and then whitewashed). There were also bits of brick and lime mortar with ground shells. They were therefore subject to continual maintenance and were repaired and rebuilt on the same site for many hundreds of years. Their age is not readily determinable, if at all.

6. Crosby Hall

Crosby Hall has been the home of the Blundell family for over 750 years, ever since they acquired the manor of Little Crosby through marriage with the Molyneuxs of Sefton in 1362. They are descended from Robert de Einulvesdel (Ainsdale), who held the manor there in around 1160. The earliest mention of a hall at Little Crosby is in a document dated AD 1275, and even then it is referred to as the 'Old Hall'. The present hall, Grade II* listed, dates from around 1609 and the barn may be older still. An old drawing of the hall shows a smaller building standing in front of the 1609 building, together with a large gatehouse. This seems to be an old manor house of Tudor design.

It was then in remote, unfertile and lawless country but its tranquillity and seclusion belied its upheavals and involvement in national events. The Blundells were ever faithful to

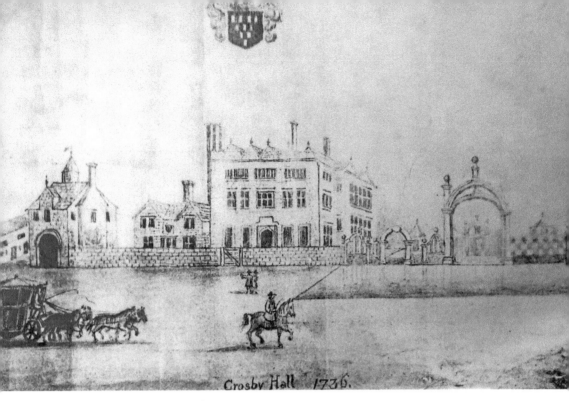

Above: Crosby Hall 1609 (front).

Below: Victorian Crosby Hall (rear).

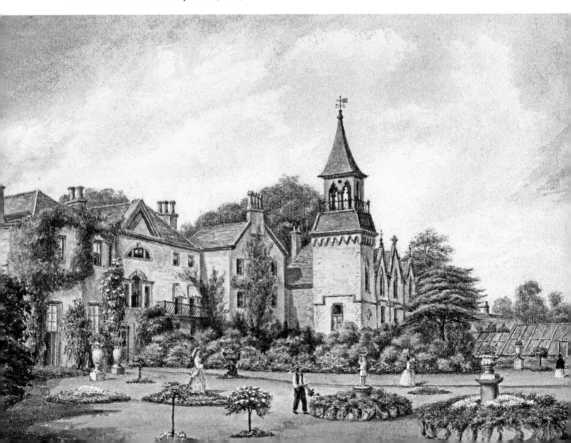

the Catholic cause and the lords of the manor suffered for their beliefs. Richard Blundell, imprisoned in Lancaster Castle for harbouring a priest, died there in 1592. His son, William 'the Recusant', was also imprisoned both there and in London. His grandson, William 'the Cavalier', fought for the Royalists in the Civil War. There is a priest's hole in the house where he would hide to escape detection. The walls around the estate were built in the early nineteenth century, enclosing a secret Catholic burial ground.

The Tudor manor house and the gatehouse were pulled down when some extensive alterations and additions were made to the 1609 building in 1784–86. Various later Victorian wings were added to the structure to give it a somewhat rambling appearance but some demolition and alterations, carried out in 1953–55, have brought the building back again to the dignified symmetrical structure it was in 1609.

7. Merchant Taylors' School for Girls Library, Crosby

In 1555 John Harrison, a successful local sheep farmer and wool merchant, left Crosby for London and made a fortune there as a member of the Merchant Taylors Guild. His son, also John Harrison, who took over his father's business, left money in his will for a school in Great Crosby to be known as Merchant Taylors. Started in 1620, it was one of the few stone buildings in south-west Lancashire. It was constructed by local masons of local freestone, each stone bearing a mason's mark. For the place and the period, it was outstanding. Great Crosby was desolate, surrounded by marsh and moorland, with poor

Merchant Taylors' School for Girls Library.

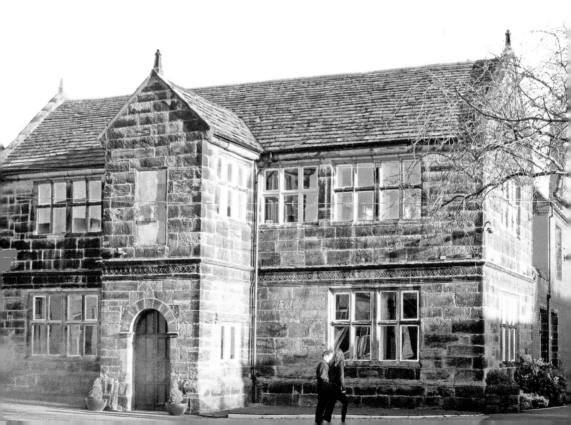

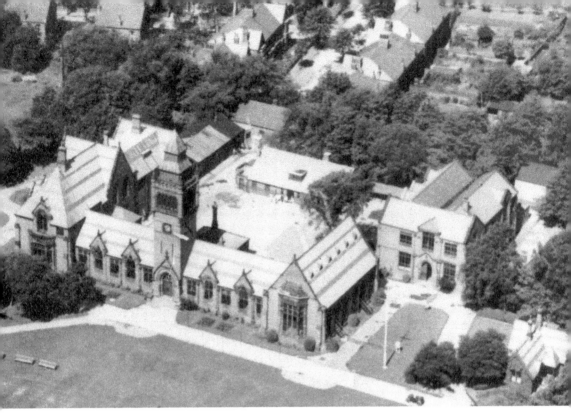

An aerial photo from 1948 of Merchant Taylors' School for Boys predates the Williams Hall, science block, gym, swimming pool and the tarmacking of the parade ground.

arable fields and pasture. The village contained barely a hundred inhabitants but the school could accommodate sixty scholars, although it opened with only thirty.

There was a large school room on the ground floor with lodgings above for an usher and maidservants. The small space that jutted out over the entrance was known as the 'birch room', where the boys were punished. The space over the doorway was filled by a sundial in the 1950s but the rest, apart from the corridor attachment at the rear, is unchanged. The plain but beautifully balanced design of the windows is enhanced by the arch over the doorway (with just a hint of classical decoration), finials over the gables and the delicate patterned frieze between the storeys.

By 1870 it was clear that the existing accommodation could not cope with the increasing numbers of boys in spite of the upper storey being converted to teaching purposes. So a spacious new building was constructed in Victorian Gothic style nearby for the boys, and a girls' school was opened in the old building in 1888. It is now the school library, a treasured centrepiece of an attractive campus that has grown up around it.

8. Ned Howard's Cottage (the Priest's House), Little Crosby

Following the Reformation, Little Crosby remained staunchly Catholic even though Catholics were punished for celebrating mass. This was held secretly at Crosby Hall both for the benefit of the family who lived there and also the villagers and neighbourhood. In 1707 Robert Aldred, a priest, came to live in Crosby Hall but there was friction between

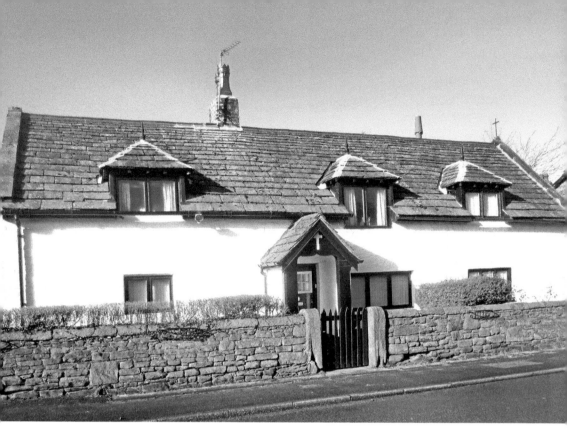

Above: Ned Howard's Cottage.

Below: Ned Howard's Cottage in the 1860s – one of Colonel Nicholas Blundell's watercolours.

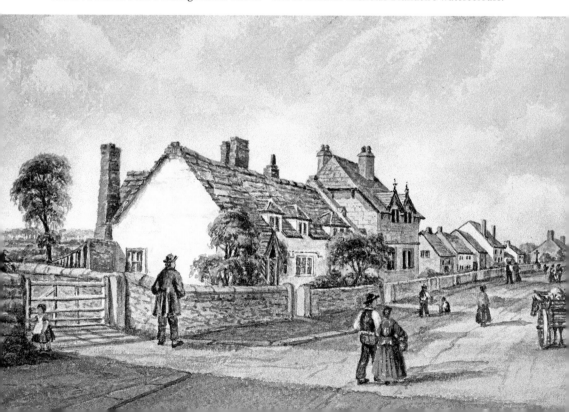

him and Frances, wife of Nicholas Blundell 'the Diarist', then squire. Nicholas records in his diary that seven months later, when Ned Howerd was out of Little Crosby, he settled him in Ned's cottage. On the gable end at the right of the cottage there is a small metal cross marking the attic where mass was secretly celebrated. In 1719 Nicholas Blundell began to build a new house and chapel, probably the first Roman Catholic chapel to be built in England since the Reformation. It is situated next to where the church is now, which was built in 1843 by William Blundell 'Fundator', its 'Founder'.

There is also a barn in the village dating from the seventeenth century with at least three other cottages of the same period (one helpfully labelled 1669) and a smithy bearing the date 1713. These and Victorian additions built by Colonel Nicholas Blundell were painted by him in the 1860s in a series of watercolours. They demonstrate how little the village has changed from his day to ours, apart from the Edwardian additions of Francis Nicholas Blundell.

9. St Cuthbert's Church, Churchtown

St Cuthbert's is the oldest church and public building in Southport, dating from 1730. It was the original church of North Meols parish, which stretched from Hundred End in the north-west to Woodvale in the south-west and so it is mother of all the other Anglican churches in Southport.

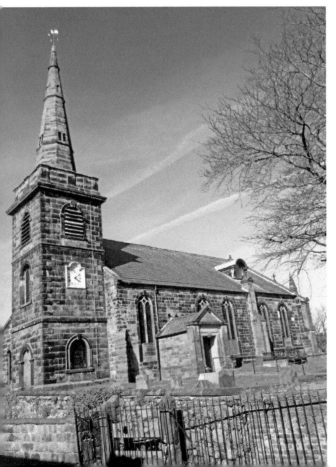

Built into a recess of the St Cuthbert's church wall in 1741 are stocks (foreground) last used in 1860 to punish John Rimmer for drunkenness. The inscription is barely decipherable.

St Cuthbert was prior of Lindisfarne in the seventh century. In the ninth century, his coffin was carried by monks round the north of England to save it from desecration by invading Vikings and it could easily be that it rested here on its journey to Durham, where he is buried in the cathedral. Crosses and churches were erected at many of the resting places. North Meols was mentioned in the Domesday Book and Adam the clerk is recorded in 1178 at the head of the list of rectors on wooden boards inside the church. The present building dates from 1739 but with substantial rebuilding and alterations from the nineteenth and early twentieth centuries.

A painted wooden board gives a list of benefactors of North Meols Grammar School. First on the list dated 1684 is Revd James Starkey, rector. In 1692 £20 was given by Richard Ball, 'lost' by Daniel Ambrose (how?) and 'made up' by Lawrence Jump.

An outstanding rector was Charles Hesketh. Described as 'indefatigable', he immediately founded North Meols lending library in 1836 and became lord of the manor in 1842. He was appointed one of the Southport Improvement Commissioners established under the terms of an act of 1846 to improve the paving, draining, policing and lighting of the 'Town, Hamlet or Village' of Southport. In 1868 he gifted the land called 'Happy Valley' for Hesketh Park, designed by Paxton (of Crystal Palace fame).

Between the church and the thatched cottage (already featured) is the old school. Founded by the end of the seventeenth century as a grammar school, it was replaced in 1826 by national (primary) schools. The plaques for the boys' and girls' schools can be seen on the walls together with the one recording the enlargement of 1837 to create an infants' school. New premises were built for it nearby in 1859 and it has since been used for other purposes, at present the Conservative Club.

An old postcard shows the schools of 1826 in the centre and the thatched cottage to the left already featured.

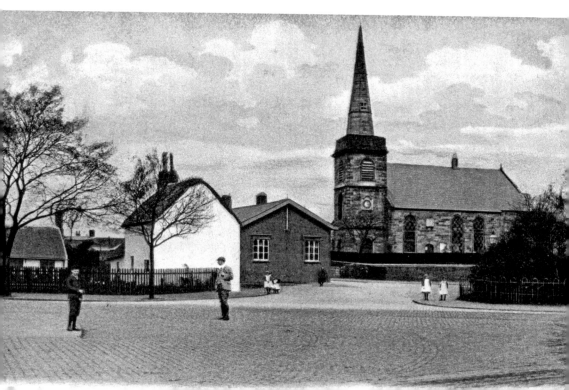

10. Ince Blundell Hall

In the nineteenth century the hall was visited by tourists for its magnificent art. Henry Blundell of Ince had started collecting in 1777 and built a garden temple in the grounds to house his antiquities. Around 1802, to display his growing collection, he had a much larger 'Pantheon' built, whose design is based on the temple of that name in Rome. The hall's ancient sculptures are now on show in the Walker's sculpture gallery (or in storage). They are the only surviving collection of an eighteenth-century dilettante for which the buildings designed to display it are still standing. Henry also put the finishing touches to the hall, which had been built by his predecessor Robert Blundell between around 1720 and 1750. The façade is embellished in classical style by columns with Corinthian capitals and pediments over the ground-floor windows. It resembled Buckingham House (later enlarged into the palace). Henry's son, Charles, was also a collector of old masters including works by Mantegna, Correggio, Tintoretto and Rubens. The acquisition of the paintings by 'T Walker' in the 1990s put it among the top five art galleries in Britain.

The Blundells (not related to the Blundells of Crosby) had come to Ince by 1180. During the Elizabethan age, and afterwards, they suffered for their Catholicism but Robert and Henry benefited from the relaxation of penalties, good husbandry and profitable marriages. Unfortunately, Henry quarrelled with his son, mainly because he refused to marry, and left all his estates but Ince Blundell to his daughters. In spite, Charles, who had received just Ince Blundell, left it in his will to distant relatives, the Welds of Lulworth, who took up residence in 1840 and developed the land. However, dilapidations caused by the war and punitive taxation forced them to sell the estate, which was taken on by the Augustinian sisters. In 1960 it was opened as a nursing home.

The Garden Temple. The inscription (from Virgil's Georgics) reads 'HIC VER ADSIDUUM ATQUE ALIENIS MENSIBUS AESTAS' ('here is spring eternal and summer in months not its own').

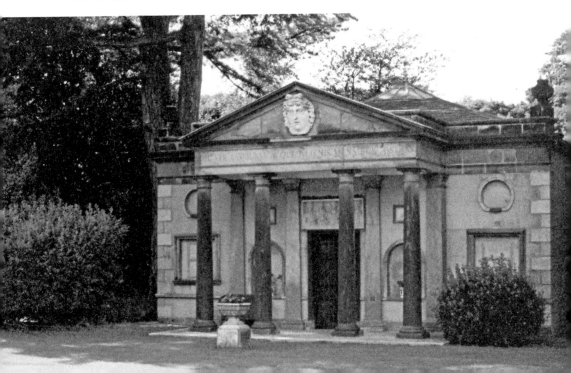

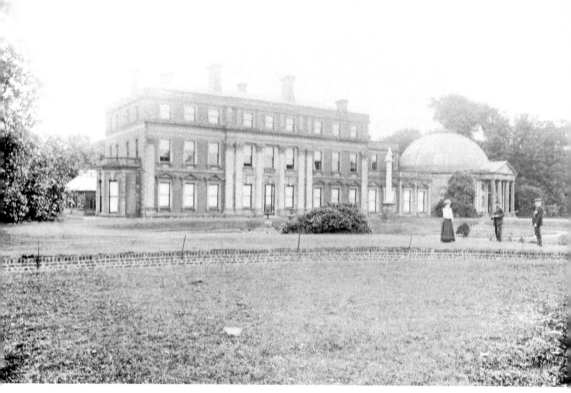

Ince Blundell Hall. The careful composition of the shooting party draws attention to the 'Pantheon', appropriately added to the hall (on the right). These, the Temple, the Old Hall, the Chapel and the Park are all listed Grade II*, far and away the greatest number in one location in the borough.

11. St Peter's Church, Formby

St Peter's Church, Green Lane, Formby, is the successor to an ancient chapel documented from as early as the twelfth century. This stood near to where St Luke's is now but by the eighteenth century, because of the hostile elements, the village had moved inland to its present site and the chapel was isolated in the sand hills. Then, in 1739, it was seriously damaged in a storm and it was decided to rebuild it one and a half miles inland on its present site.

The new Georgian church of 1747 is noteworthy for its windows, remaining gallery and cupola in that style. A sundial in the churchyard, dating from 1719, is a link with the old chapel. In the nineteenth century, the squires of the manor of Formby who lived in Formby Hall were also incumbents of St Peter's. The granddaughter of one of them (Richard Formby) wrote 'The Church at Formby was and is still quite unlike what a church should be'. This was in keeping with the feeling of the age – spearheaded by Pugin – that churches should be built in the Gothic style. It was proposed to demolish and replace it.

However, a Gothic chancel and chapel (in memory of Richard) were added on instead. This has fortunately preserved the Georgian features – rare in this area – although it has resulted in an incongruous mix of styles. The timbered roof was built at the end of the nineteenth century.

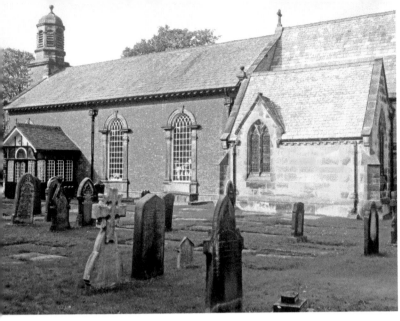

St Peter's Church.

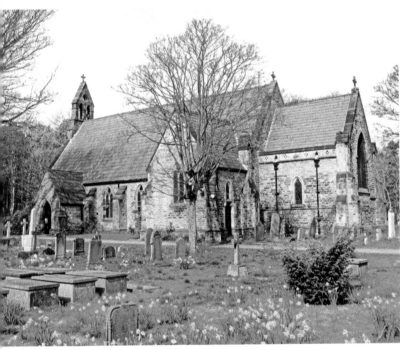

St Luke's Church.

In the meantime, Richard Formby's brother, Miles, vicar of St Thomas, Melling, had stuck a stick in the ground near to the site of the old chapel saying prophetically to Henry Aindow 'I think you will live to see another church built here'. The need for a church created by the coming of the railway and consequent development of housing fulfilled his prophecy, and St Luke's was built in 1852 in pure Gothic style. Inside is the font from the old chapel dating from the Norman period. In the graveyard are interesting relics: the old village stocks from Liverpool Road, a gas lamp of 1897, and the base of the cross that used to stand in the village green.

12. Old Hall, Bootle

The 'Old Hall', No. 3 Merton Road, is the oldest building in Bootle. It was originally the kitchen wing of the hunting lodge for the Earl of Derby. The lodge has mercifully survived externally in looks and inside has been adapted to residential accommodation, preserving many original features: cast-iron fireplaces and wooden beams and flooring.

The Earls of Derby resided in their nearby ancestral home Knowsley Hall. They gradually released their estate in Bootle, mostly for profit but also as a gift, especially where it benefited the public. Their family name was Stanley, hence the Stanley Arms (below), Derby Road (on which the Borough Hospital stands), Derby Park (the largest and most ornamental of Bootle's parks) and above all Stanley Road, which is the backbone of Bootle stretching end to end, south to north. Gardens opened by the Earl of Derby in 1904 were initially called Stanley but renamed King's when the Countess of Derby unveiled the statue of Edward VII.

The Old Hall used to be at the centre of the old village of Bootle, whose main street, Litherland Road, stretched down towards Litherland. In addition to the shops pictured in the 1905 photo, there was a fine array that included grocers, greengrocers, chandlers and herbalists, besides a confectioner, milliner, stationer, fishmonger, chemist and draper.

The Old Hall is on the right. A drainpipe head displays the date 1773 with the Derby family crest of an eagle and child. It has migrated to the building next door on the left of the photo and is visible between the two pairs of windows.

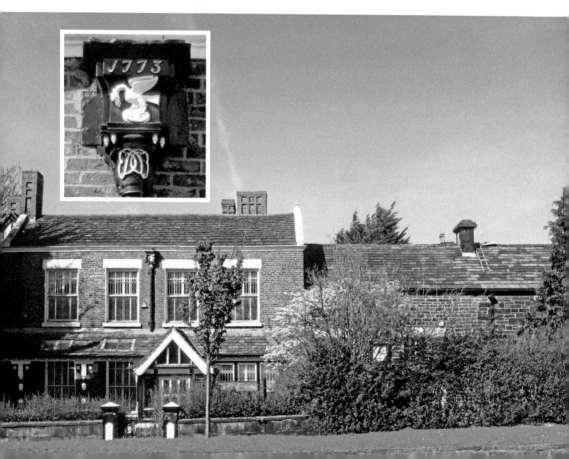

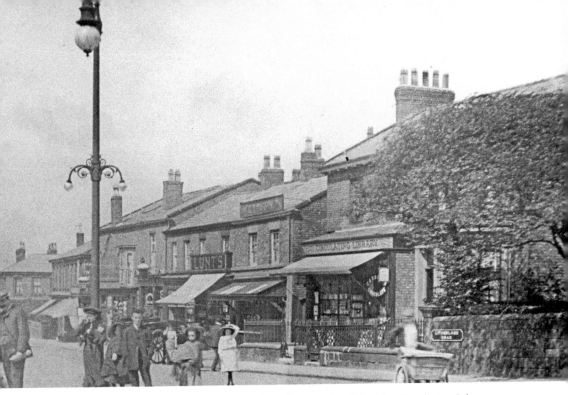

Above: Litherland Road in 1905. The first shop on the right, the Circulating Library, was opened in 1884. Then comes a butcher, Lunts (baker), a bootmaker and the Jawbone Tavern (so called because the jawbone of a whale hung over vestibule door). This is the oldest pub in Bootle dating from 1802 (when the population was only 537). Further down were the Stanley Arms and the Laburnum Hotel.

Below: Litherland Road in 2016. The Circulating Library of 1905 has since graduated from post office to convenience store. Note the gap in the next block due, no doubt, to bombing in the war. The Jawbone Tavern was rebuilt with its sign in the 1920s or '30s.

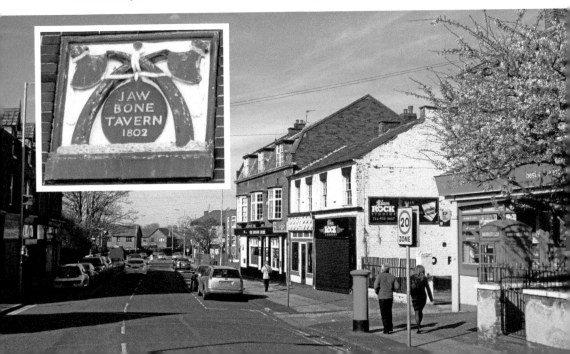

13. Hesketh Arms, Churchtown

The Hesketh Arms public house, originally three fishermen's cottages, played an important part in the birth of Southport. William Sutton, landlord of the Black Bull, as it was known then, profited from housing and transporting bathers from Churchtown to South Hawes. This was at the south-west end of Lord Street where a brook, pretentiously dubbed the Nile, flowed through the sand hills onto the shore. Known as the Old Duke, William first enlarged the accommodation at an inn known as 'The Folly' to cater for the bathers (pictured on next page). He then constructed a new bathing house on site to save them the 2-mile drive each way every day. Then, in 1798, he built a new inn called the South Port Hotel at the end of what is now Lord Street ('North Port' was possibly a bay near Churchtown, also used by smugglers). It is related that at the opening entertainment a Doctor Barton 'took a bottle of wine, and dashing its contents about him, emphatically said "This place shall be called Southport."' William's hotel – by Duke Street, which was named after him – was demolished in 1854 when Lord Street was extended through to Birkdale, but a tablet set into the wall nearby preserves the memory of his inn, his hotel and the monument which commemorated them.

The Hesketh Arms.

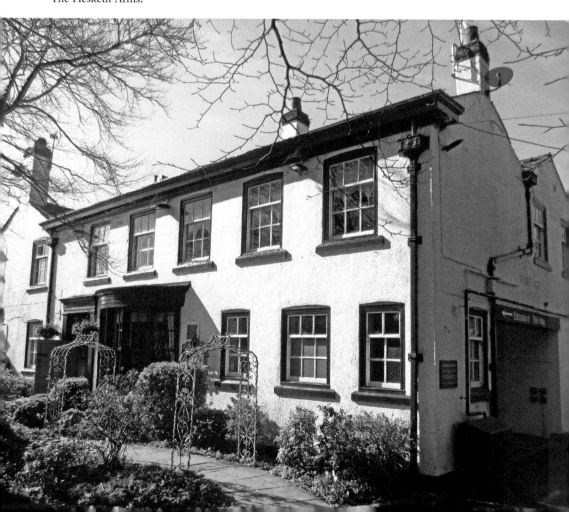

The Duke's Folly.

14. Leeds Liverpool Canal Bridge, Bootle

The Leeds Liverpool canal is said to be the longest in England constructed by a single company. Work started at both ends in 1770 and by 1774 the section from Liverpool to Newburgh had been completed. The total length of 127 miles was not finished until 1816 because of a lack of funds. A plaque on the inside of the Litherland Road bridge tells us that it was 'erected by the Corporation of Bootle cum Linacre', started in 1887 when William Jones was mayor and finished the following year. It is significant that the newly created borough, and not the canal company, built the bridge and were proud to proclaim its achievement. The ironwork on either side of the road has lasted well, although the carriageway itself has been rebuilt.

The canal was a major factor in the development of Litherland and Bootle's industries, which flourished along its banks and beyond until the Second World War. When these declined after the war, the banks became derelict but recent renewal has seen attractive residential development and the restoration of its rustic charm. The canal transported basic commodities like cotton, coal, wool and limestone, so essential for the Industrial Revolution and the creation of wealth for Liverpool, Manchester and Leeds. It also acted locally as a means of public transport before the arrival of the railway. Before the canal, Crosby folk would trudge along the beach to Liverpool in preference to the roads, which were even harder going. Now, they could walk along Endbutt ('end boat') Lane to the canal and take a barge into town.

For over a century, before George's Dock was filled in to make way for the Three Graces in the early 1900s, the canal provided a route through to the South Docks of Liverpool. Recently, this link has been restored by the construction of a new canal tunnelling its way through to the Albert Dock, thereby giving a boost to tourist traffic on the canal.

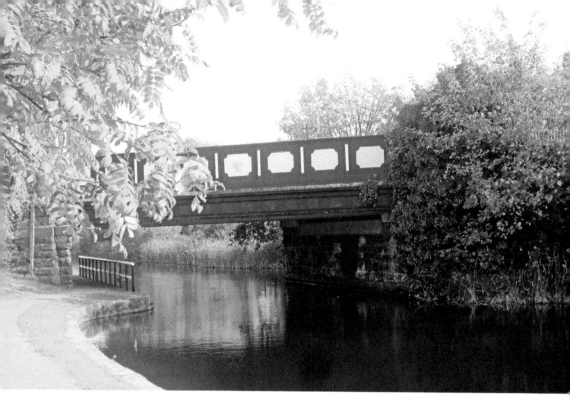

Above: Litherland Road canal bridge.

Below: Only a mile distant, a 1936 industrial scene in the heart of Bootle at Coffee House bridge.

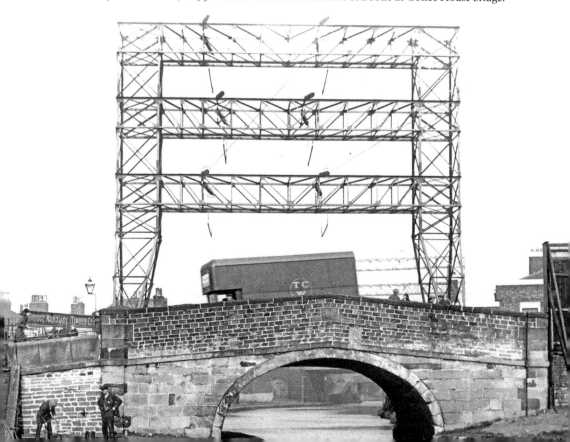

A watercolour of 1904 portrays a standard design of canal bridge in the countryside near Bootle.

15. St Benet's Chapel, Netherton

Netherton means 'nether town' (it is a few feet lower than its more ancient neighbour Sefton Township). Until the middle of the eighteenth century Catholics in the area had been able to worship in the private chapel of the Molyneux family at Sefton Hall but then the 8th Viscount renounced his Catholicism, adopted the established church and was created Earl of Sefton in 1769. In 1791 the second Roman Catholic Relief Act allowed Catholics to worship freely and Father Gregory, a Benedictine monk, raised funds to build a priest's house – hence St Benet's chapel. In spite of the protection given by the Relief Act, the existence of the chapel was disguised by being hidden away behind the priest's house as in the days of persecution. Completed in 1793, the church is the only Grade II*-listed building in the former borough of Bootle. Services were last held there in 1975 when the new church was built close by. The presbytery was restored in 2004 and is used as a residence for retired priests. The chapel is undergoing restoration in a way to present it as it would have been before the Second Vatican Council.

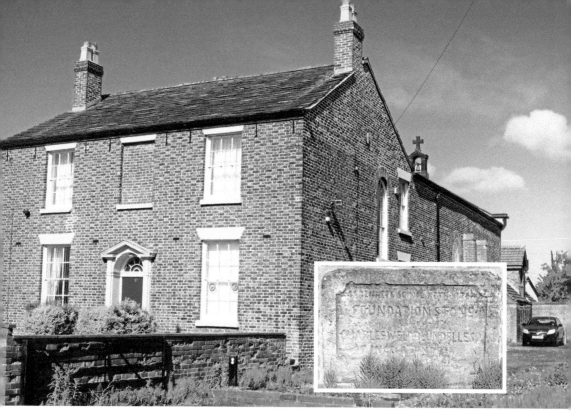

Above: St Benet's Chapel. A plaque (right of car and inset) records the foundation of St Benet's School, Netherton, by Charles Weld Blundell (of Ince Blundell, 1844–1927). Note Ben(n)et and Blundell(es).

Below: St Benet's interior.

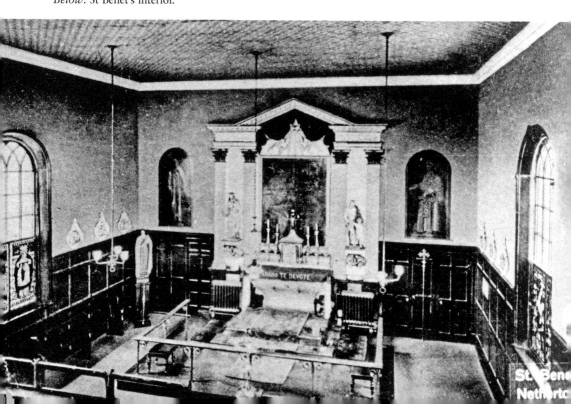

16. Windmill, Crosby

A windmill was recorded in Little Crosby as early as 1275. Besides being essential for everyone's daily bread, the mill was also a useful source of income for the lord of the manor. It was a great disaster when in 1710 the mill was destroyed and every effort was made to reopen it two months later. The village tailor was employed to remake the sails (as he did each year, besides running repairs). When the Crosby Hall estate was enclosed in 1813, the mill was relocated on higher ground to nearby Moor Lane. It survived the great storm of 1839, although the sails were set spinning so fast that there was danger of fire from the overheated gear wheels. To compensate for the lack of wind, steam power was introduced in 1855 and the sails began to deteriorate. Electricity replaced steam in the 1940s and in the 1970s there was a plan to demolish the mill and develop the site for housing. The mill was saved by public protest, and an enterprising builder who converted it into a dwelling.

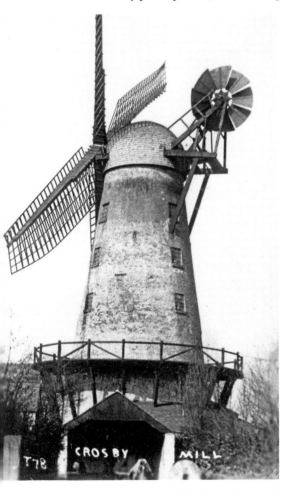 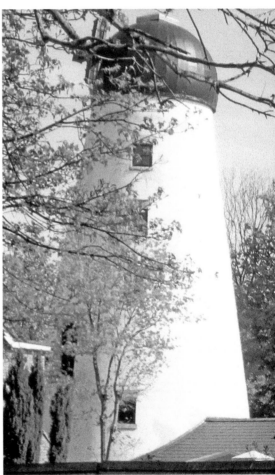

Above left: Crosby Mill in the early twentieth century.

Above right: Crosby Mill, 2013.

17. Royal Hotel, Waterloo

In 1815, the year of the Battle of Waterloo, 'Seabank' Hotel was built by 'fine hard sands' 5 miles north of Liverpool. This, with six adjacent cottages, was to cater for the increasing popularity of sea bathing. The first anniversary of the battle was celebrated in grand style in the hotel, then called the Waterloo Hotel and now the Royal Hotel. The growing township was given the same name, which became an administrative district with Seaforth in 1861 and part of the borough of Crosby in 1937. The Town Hall buildings survive in St George's Road.

For over a century the sands and bathing machines attracted more and more bathers, helped by the Overhead Railway with its tram extension from Seaforth Sands station to Crosby. Then the docks spread northwards: Gladstone Dock came to Seaforth in 1927 and the Royal Seaforth Container Dock in 1973 to the very edge of Waterloo. Meanwhile the seafront by the hotel itself was enhanced in the 1930s by a series of gardens and later a marina, protected by a sea wall promenade. The much-depleted sea shore is now the southern end of Another Place, home of Antony Gormley's Iron Men.

The original cottages by the hotel were later known as Marine Terrace and this was later extended by a series of three terraces culminating in a grand house, Beach Lawn. Commemorated by a blue plaque, this was the home of Thomas Ismay and his son Joseph Bruce Ismay. Born in Crosby in 1862, Bruce became managing director of the White Star Line, which owned the *Titanic*, and White Star ships would salute as they passed the residence. John Smith, captain of the *Titanic*, lived at No. 4 and later No. 17 Marine Crescent, which sports a blue plaque in recognition of him.

The Royal Hotel in the 1930s very soon after the gardens had opened. The top of the old cranes in the Gladstone Dock can be seen on the right in the distance. Now, the container cranes of the new Seaforth Dock form the background.

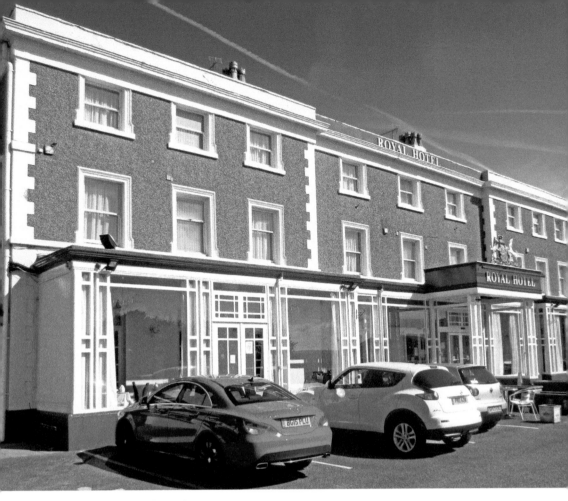

Above: The Royal Hotel.

Below: A pre-war look along the terraces towards Beach Lawn at the end in the distance.

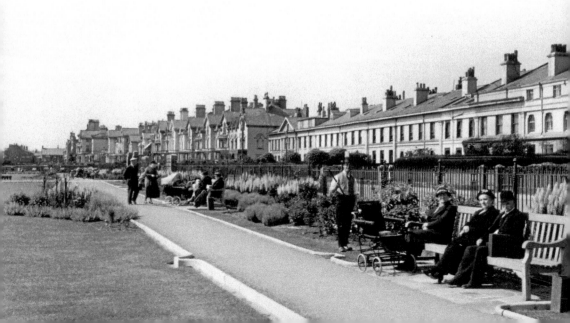

18. Royal Clifton Hotel, Southport

The Royal Hotel is a direct descendant of the 'The Folly', Duke' William Sutton's original structure of 1792 that was the making of Southport. When its successor was pulled down, the license was transferred to the Royal, the building we see now on the corner of the Promenade and Coronation Row. This was in 1853, and is recognisable by the plain architecture of the first three bays of the establishment. The Italianate tower is integral to the design of the hotel as it held the water tank to supply the hotel. It also acted as a landmark in the Southport landscape, being effectively at fourth-floor level – good publicity and a happy combination of design and utility. The first extension of 1865, north of the portico, is built in a more ornate style than the original, distinguished by the graceful flowing lines of its round headed windows and curved glass. The Clifton Hotel next door along the promenade was built in the plainer style and came under one ownership with the Royal in the 1970s. The single-storey octagons on the corner were added by local architect Martin Perry in the late 1980s.

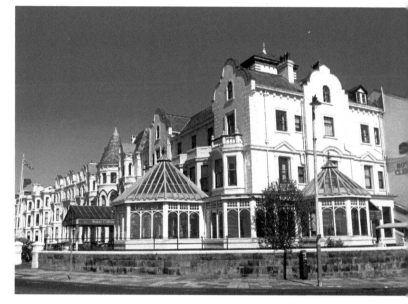

The Royal
Clifton Hotel.

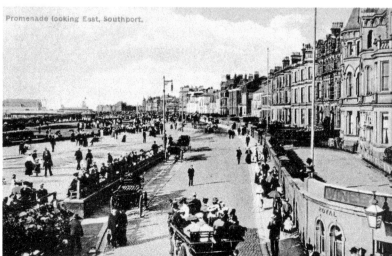

This Edwardian view shows how the hotel vaults accessed from the lower street level in Victorian times would have been opened to the public as a bar. The Promenade really was a promenade then!

The ballroom/dining room of the Royal Clifton is beautifully decorated in Classical style with Roman arch doorways and Renaissance Ionic pilasters.

19. St Luke's Church, Crosby

St Luke's Church is a link with the past through time immemorial. Viking invaders, it seems, found a well, whose healing waters were dedicated to St Michael, and christened the place 'Crosby' ('the village with the cross'). A replica of the original cross, which stood for centuries on the village green, has been erected nearby. From at least the sixteenth century worship was conducted in a series of chapels dedicated to St Michael. For over two centuries, the priest in charge was also headmaster of the neighbouring Merchant Taylors' School. The last of the chapels proved inadequate to accommodate a congregation swollen by the advent of the railway in 1848 and a replacement church dedicated to St Luke was consecrated on Boxing Day 1853 in the fashionable Gothic style of the day. The materials from St Michael's Chapel were then used to build a church school instead on its site. When this too was demolished in 1974, some bricks were saved to create a seat by the pathway leading up to the church.

The glory of St Luke's is in its ten transept windows. Most of them, dedicated to the Houghton family, were created by the Belgian Capronnier, who did much to revive the art of glass painting, and won the only medal for glass painting at the Paris Exhibition of 1855. After a near disastrous fire in 1972 they were renovated to their original brilliance but a

St Luke's Church and the graveyard, which has won awards for the beauty of its flora and good ecological practice involving the community.

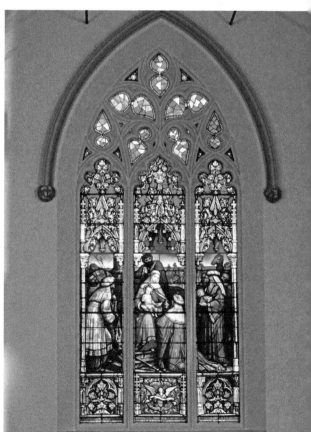

A Capronnier window depicting the nativity.

new roof and chancel had to be built. Recently the church has been reordered allowing a view from outside the entrance through to the altar.

Originally a daughter church of Sefton, St Luke's founded St Michael's, Blundellsands, in 1907, All Saints in 1934, and in 2016 Storyhouse, a mission café church in the heart of Crosby.

The graveyard was consecrated for the burial of the first vicar, Richard Walker, who died only a few weeks after the church was dedicated. Various extensions were added between 1905 and 1947. Six thousand plots were then available covering four and a half acres with around 20,000 burials. The cemetery in Thornton is now used for most Crosby burials as there are now only a very few plots left at St Luke's and new graves are reserved for members of the church.

20. Town Hall, Southport

The Town Hall was the first (in 1854) of an impressive array of buildings in classical style stretching from Christ Church to East Bank Street. The hall's crowning glory is a triangular pediment embellished with symbolic figures. Neighbouring Cambridge Hall (1874) was named after Princess Mary of Cambridge, mother of Queen Mary. It was designed for public meetings and entertainments, which ranged from spelling bees to Moody and Sankey

The pediment of Southport Town Hall depicts justice in the centre with her scales of judgment, mercy to the left sparing a prisoner and truth to the right holding up a mirror to herself. The patriotic flags are in distinct contrast to those being flown in the picture of 1906.

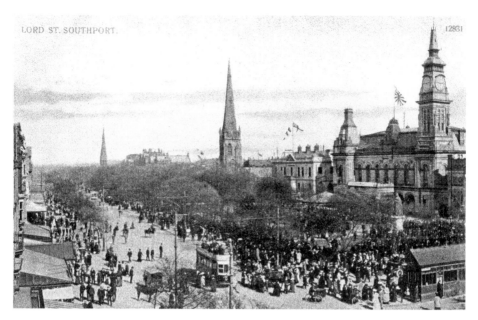

LORD ST. SOUTHPORT. 12831

Above: Lord Street in 1906 showing the Town Hall centre right. Just beyond the Town Hall, the spire of Christ Church, dating from 1862, was taken down in 1952 as it was unsafe. Further along is the spire of St George's United Reformed Church (formerly the English Presbyterian church) dating from 1874. Pennants hover above the Town Hall and the Japanese flag is being flown above Cambridge Hall.

Right: Menu for a dinner held by the mayor in 1906 at the Meols Hall 'Rookery' (now demolished). The Japanese visitors were treated to seven dishes including oysters, soup, lobster, pigeon, gateau mocha, pate de foie gras and brown bread ice.

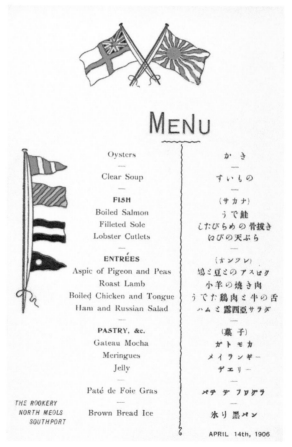

MENU

Oysters	かき
Clear Soup	すいもの
FISH	（サカナ）
Boiled Salmon	うで鮭
Filleted Sole	したびらめの骨抜き
Lobster Cutlets	ねびの天ぷら
ENTRÉES	（ｵﾝﾂﾚ）
Aspic of Pigeon and Peas	鳩と豆とのアスヒタ
Roast Lamb	小羊の焼き肉
Boiled Chicken and Tongue	うでた鶏肉と牛の舌
Ham and Russian Salad	ハムと露西亞サラダ
PASTRY, &c.	（菓子）
Gateau Mocha	ガトモカ
Meringues	メイランギー
Jelly	ゼエリー
Paté de Foie Gras	ﾟﾃ ﾃﾞ ﾌﾜｸﾞﾗ
Brown Bread Ice	氷り黒ﾊﾟﾝ

THE ROOKERY
NORTH MEOLS
SOUTHPORT

APRIL 14th, 1906

revivalist gatherings. Then, in 1875, William Atkinson, a wealthy cotton manufacturer, donated a free public library and art gallery (now 'The Atkinson'). In 1879 the Southport and West Lancashire Bank opened its 'very ornate' premises on the corner of Lord Street and Eastbank Street, which became the Manchester & Liverpool District Bank (later the District Bank) in 1879. This is now the reading room of the public library.

VIPs from abroad came to Southport as a place of entertainment and residence in preference to Liverpool. Nathaniel Hawthorne, author and USA consul in Liverpool, resided in Southport because of the health of his wife in the 1850s. In 1906 Japanese visitors were entertained in connection with the building (in Newcastle on Tyne) of the Japanese warship *Kashima* during the Russo-Japanese War. The Japanese were probably en route to sailing from Liverpool but a substantial dinner and tea featuring national and local cuisine was held in their honour at Southport Town Hall presided over by the mayor, 'Chas H B Hesketh Esq'. He also provided a private dinner (much more lavish than the one funded by the Corporation!) in his home at Meols Hall.

21. The Pier, Southport

Southport Pier was opened in 1860 at the height of the pier building era. It was the longest in the country, the first to be built of iron, the first genuine pleasure pier and the first to be constructed with pressurised water being used to drill holes into the sand for cast-iron piles. It is hard to believe now, when the sea barely reaches the end of the pier, that steam ships would berth at the end of it bringing holidaymakers not just from Liverpool and Blackpool

Sailing ships can be seen both sides of Southport pier in 1904 while a plume of smoke tells us that a steamship is at the end of it. The shelter in the foreground to the left is still here. The postcard is undivided on the reverse with no space there for the message, which at that time had to be put on the front.

Southport.

The Pier.

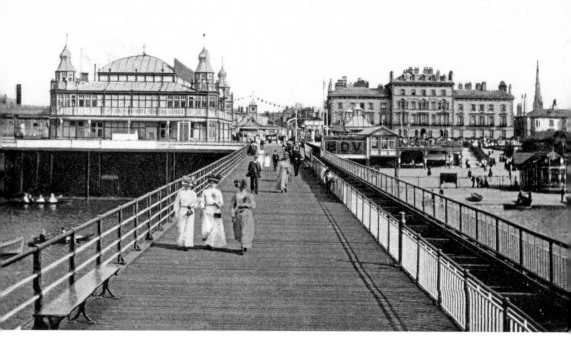

Above: The Pier Pavilion, with its spiked Islamic cupolas, was replaced in 1970.

Below: Battery-powered train on the pier, 2017.

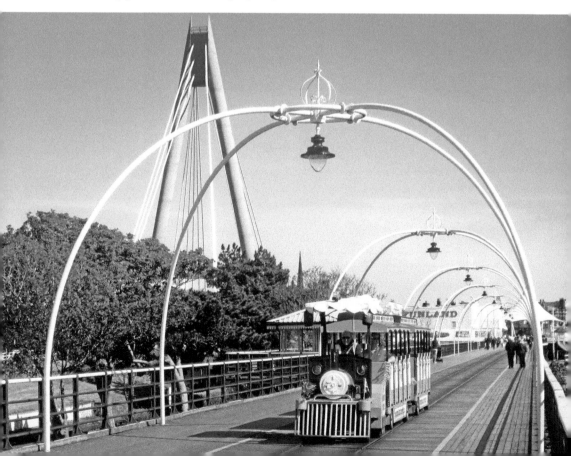

but as far as the Isle of Man and Anglesey (an operation that ceased in the early 1920s). The pier's 1,200 yards was later extended by 260 yards to reach the deep-water channel. Visitors could take a tram to waiting and refreshment rooms, which were, however, swept away by a storm in 1889. People flocked to admire the distant scenery and the crowd of fishing boats and pleasure vessels at the head of the pier where a one-legged diver or the legendary Professor Powsey gave their diving displays. The Professor would pedal off the edge of the pier, or dive, on fire or tied up in a sack.

The tramway was horse drawn at first but later powered by steam to become the first cable operated tramway for passengers in the world. Electrification came in 1905 and diesel haulage in 1950 when the pier lost its DC electricity supply. The 3-feet 6-inch gauge was replaced by a much dinkier 1 feet 11½ gauge. This in turn gave way to a much larger battery-powered tram, which weakened the structure and was recently sold, but the little train still struggles on. What next?

The pier's greatest drama came in 1990 when a demolition proposal was rejected by the Sefton's Leisure Services Committee by only one vote. The pier, the second largest in the country after Southend, was saved by the Southport Pier Trust, the Lottery Fund and European Merseyside Objective. It has now received a grant to create bird-watching facilities.

22. Borough Hospital, Bootle

In the 1860s Bootle became increasingly worried by the encroachment of Liverpool's housing and docks on its boundaries. In 1868 a deputation was formed to petition the Privy Council for a charter to be granted to the township of Bootle-cum-Linacre. On their successful return the charter was paraded through the streets on 5 January 1869. A new hospital was an immediate priority. Land was gifted by the 14th Earl of Derby (three times prime minister of the United Kingdom and to date the longest serving leader of the Conservative party), the foundation stone was laid in 1870 by the 15th Earl and the hospital was opened in 1872. Funds were raised by voluntary contributions including Thomas Henry Ismay, owner of the White Star Line, who also contributed to the running costs. The architect was Christopher Obie Ellison, first president of Society of Architects in 1884, who designed the extensions of 1885–87 and also many other listed buildings in the area related to health and welfare. In the early 1900s it was given a royal charter and plans were made to extend it further as a memorial to Edward VII. However, only a nurses' home was built, in 1915, used initially for soldiers wounded in the First World War. An outpatients department was constructed behind the nurses' home along Nelson Street in 1932. The hospital was evacuated at the start of the Second World War, because of its proximity to the bombing of the docks. It was reopened after renovation in 1947 but closed in 1974 and continues in the medical line as Mast Laboratories. The complete set of buildings remains and externally presents a most imposing example of Victorian institutional architecture. Most of the internal features of the hospital buildings survive too, including the mortuary chapel.

Bootle's coat of arms and motto convey the status of the new borough: *'respice aspice prospice'* ('look to the past, the present and the future'). Bootle, proud of its independent status and identity, seized many opportunities to display it. Recently, modern sculptural versions have been erected at each end of Stanley Road, explaining Bootle's motto in modern terms: *respice* (reflect on the past) *aspice* (consider the present) *prospice* (provide for the future).

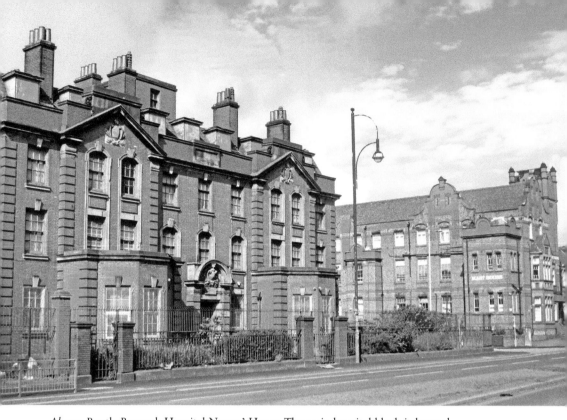

Above: Bootle Borough Hospital Nurses' Home. The main hospital block is beyond.

Below: Bootle coat of arms and motto above the Nurses' Home entrance.

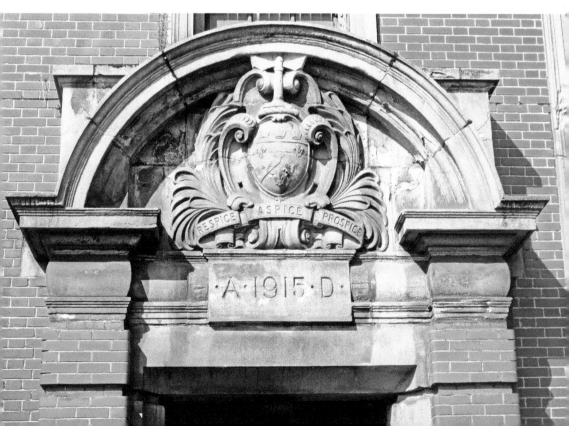

23. Botanic Gardens, Southport

'The Southport folk can skate on real ice in July, and sit under palm trees at Christmas' said Lord Derby when the Botanic Gardens were opened by Revd Charles Hesketh in 1875. Previously, the principal attraction to visitors in Churchtown, and in Southport as a whole, was the 'Strawberry Garden' where visitors could enjoy strawberries and cream under cover. The Botanic Gardens made use of a pool that served as an eel fishery in medieval times and were created by the Southport and Churchtown Gardens Co. This was a group of working men who acquired the land from the Hesketh Estate and raised £18,000 (nearly £2 million today) to build the museum and conservatory, and landscape the gardens. Visitors were charged 4*d* for entry to a variety of attractions, which at one time included boats on the lake, a monkey house and more recently a road train. Only an aviary has survived. When the Botanic Gardens Co. failed in 1933, the gardens were purchased in 1936 by the Corporation with generous aid from Roger Fleetwood Hesketh and reopened with playing fields as a memorial to George V. Besides the large glass conservatory the gardens boasted a fernery, which proved very popular with visitors as it featured many tropical plants from around the world. Although the magnificent conservatory was eventually demolished, the fernery still remains. The site of the conservatory can still be seen in front of the fernery today, as the outline of the remains is laid out as a floral garden.

Botanic Gardens, the conservatory with boats on the lake.

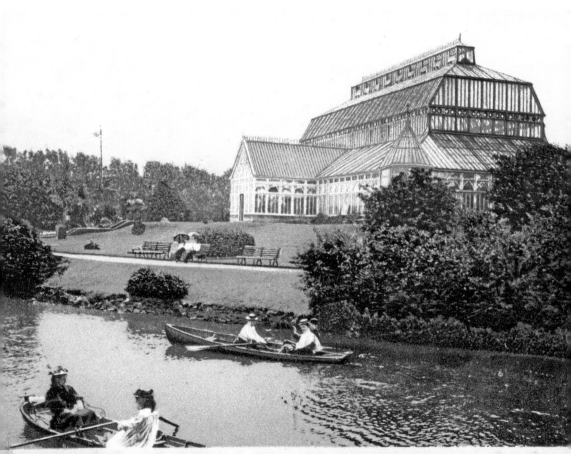

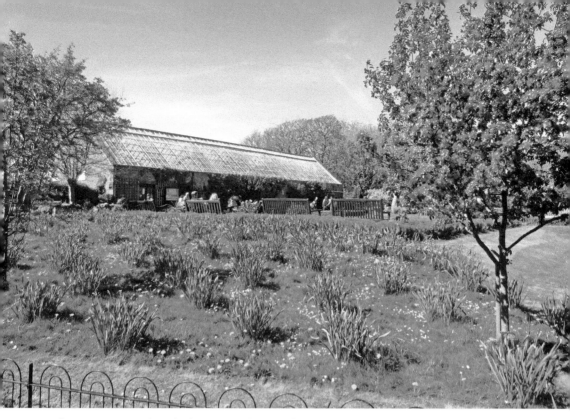

Above: Botanic Gardens, looking across the site of the conservatory to the fernery.

Below: Botanic Gardens Museum.

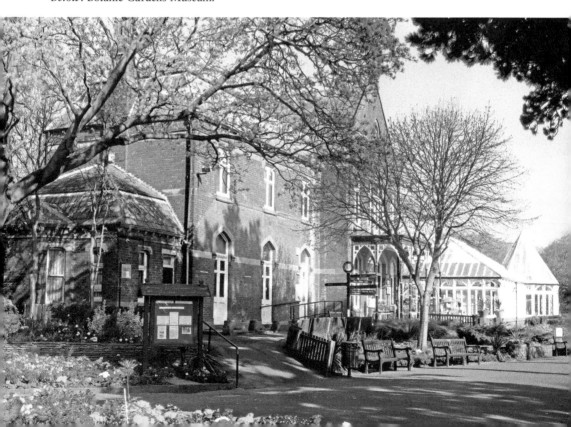

The foundation stone of the Botanic Gardens Museum was laid at the same time as the opening of the gardens and opened in the following year as a private company. The collection, consisting mainly of curiosities, was sold in 1933 when the company failed. A Southport Municipal Museum was opened in its stead in 1938 and a new collection was built up including items of local artistic, scientific, historical and cultural interest. This included the Cecily Bate collection of dolls, the Pennington collection of birds, now transferred to the British Historical Taxidermy Society Trust based in Essex, and an ancient canoe from Martin Mere, now in the Atkinson Museum. However, due to council cutbacks, it was closed again in 2011; the grand Victorian building has remained empty ever since.

24. Abigail Rest Home, Bootle

The initials 'WJ' on the keystone over the doorway of No. 9 Merton Road, Bootle, point to the building of hundreds of terrace houses in the area. Having made a fortune out of the development of streets named after places in the land of his fathers – Rhyl, Holywell, Flint, Denbigh, Conway and Bala – William Jones purchased this imposing residence in 1885 and stayed until 1917, marking it for his own. Ironically William had made his

Abigail Rest Home. The grand Corinthian bay window on the left contrasts with a plainer Tuscan style on the less ostentatious window to the right. Corinthian prevails on the first floor with graduated, balanced Romanesque arches, reflecting the doorway. Above that the Classical ornamentation of the top floor is crowned by an observatory on the roof.

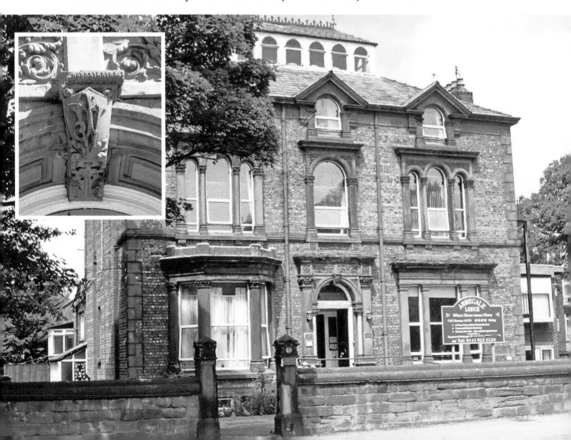

money out of the sale of the estates of even grander houses that had preceded No. 9 Merton Road. The Welsh Streets, built on the land of Bootle Hall, have been replaced by tower blocks and names that bear no resemblance to their predecessors. William was nicknamed Klondyke because of his wealth, and a housing estate of his was referred to as The Klondyke, including Eleanor Road pictured in 2014 before its redevelopment. Did the name refer to a relation or friend? Neighbouring Willard Street, which has now disappeared, is a conflation of his grandsons' names, William and Richard. Were Annie, Marion, Mary, Elizabeth and Edith part of his life, distinguished by the title of Road, not Street?

No. 9 Merton Road was one of many such grand houses of its time but one of the few that has survived bombing and redevelopment (only forty of Bootle's 17,000 houses escaped damage during the war). Ornamental Gothic gate posts invite you through to a classical doorway with Corinthian (acanthus) columns framing a Romanesque arch and smaller pillars of contrasting colour. Overhead is a highly decorated frieze.

In 1937 it was taken over as the Church Army Home for Aged Ladies known as the Sunset Home. It also housed the Bootle Food Office and canteen and club for the forces. It is now the Abigail Rest Home.

Eleanor Road before redevelopment. The name can be deduced from the only remaining letters, LEA, on the board.

25. St Andrew's Church, Maghull

St Andrew's Church was consecrated on 8 September 1880. A church hall was added in the late twentieth century.

In the graveyard is the ancient Chapel of Maghull, part of a much-altered building dating probably from the beginning of the thirteenth century and Grade II* listed. At that time it was a chapel of ease in the parish of Halsall, and, like other churches in the area, part of the diocese of Lichfield. In 1755 the medieval nave was pulled down as being too poor and small, and a new brick nave was built. This was enlarged in 1830. Shortly after this the chapel was made a parish church. However, even when enlarged the chapel proved to be too small and inconvenient for the growing population of Maghull and the present parish church was built. In 1883 the 'modern' part of the chapel was demolished and the porch was built of stone from the remnants. The west and south walls were rebuilt, and the chapel as we see it today was reroofed with the original slates.

Near the ancient chapel is the grave of Frank Hornby, who built up an empire based on Meccano and model trains, manufactured in Liverpool. The Hornby brand is still strong and his house on Station Road has a blue plaque in his honour.

St Andrew's Church.

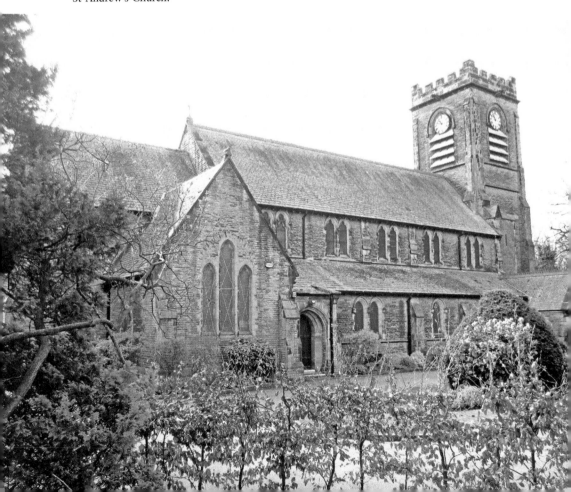

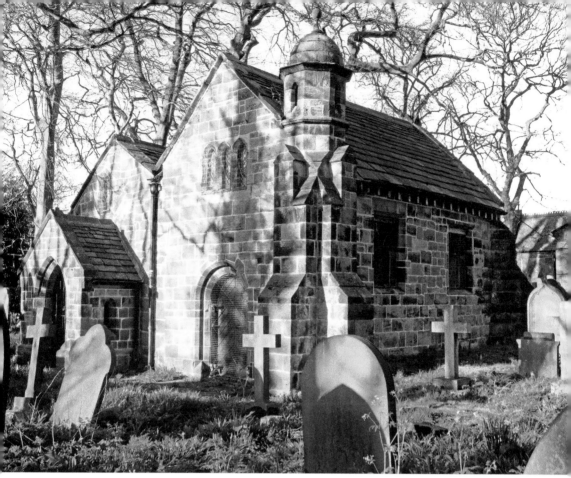

Above: The ancient chapel.

Right: Frank Hornby's grave.

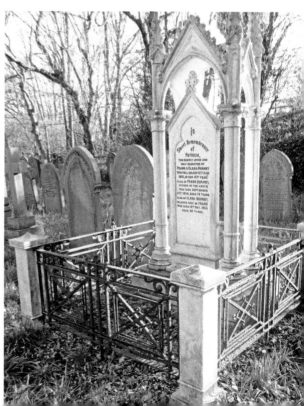

26. Harland and Wolff's Foundry, Bootle

This is the foundry of the firm that built the *Titanic*, its sister ships the *Olympic* and *Britannic*, and the Royal Navy's *Belfast*, among other well-known ships. Although the *Titanic* was built in Belfast, Harland and Wolff's engineering head offices were in Bootle and the foundry was part of their marine refit and repair shop. The company closed its Bootle operations in the 1960s when it decided to consolidate its work in Belfast. The head offices located further along the 'Dock' road were demolished in 2013, when Sefton Council unsuccessfully applied to English Heritage for the building to be listed as being of special architectural or historic interest. However, the company's foundry with its imposing façade has survived, now used mostly for storage, although part has been converted into a pub, The Rubber Duck and the premises are also used by an engineering company.

Besides the huge interior, the chimney and imposing façade survive intact. It is beautifully balanced with 'Harland and Wolff Ltd' proudly proclaimed in the most imposing blocks at each end. At the centre, the main entrance, although lower in profile than the rest, is lavishly decorated. Overall, a triangular pediment in the classical style is flanked by octagonal domes of curious design. Two slabs of stone, shaped appropriately, decorate the inside of

Harland and Wolff's foundry.

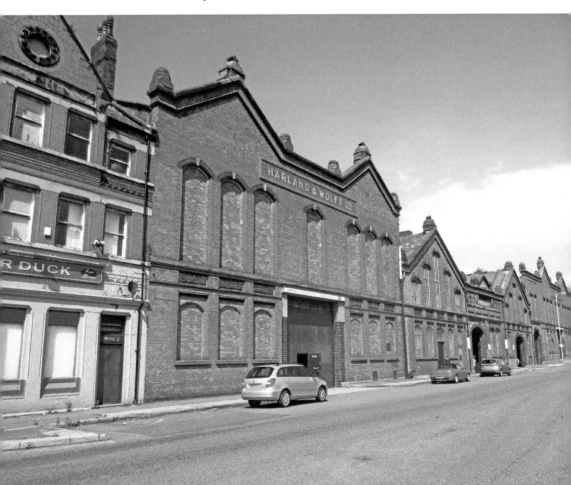

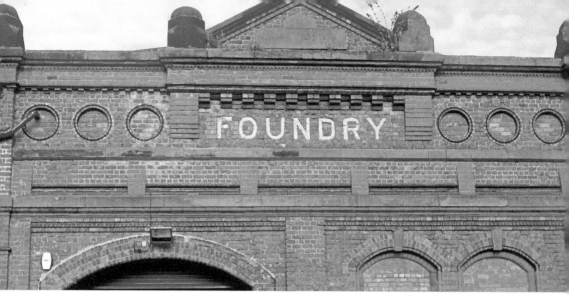

Decoration above the main entrance of the foundry.

the triangle but, although suited for the purpose, carry no inscription. Underneath the next level of bricks or cornice is dentil (tooth-shaped) decoration and below that, just above 'FOUNDRY', are corbels (supports) in stone with similar ones in brick. Decorative circles fill in the panels either side. Below that the classical motif is continued.

27. Town Hall, Bootle

The Town Hall and Municipal Offices were opened in 1882, the start of a civic centre complex that was to occupy two sides of a huge block. Next to The Town Hall, the opening of the Free Library and Museum building coincided with the celebration of the Jubilee of Queen Victoria in 1887. The line of buildings was completed by the police buildings and post office. Round the corner on Balliol Road, the public baths were opened in 1888 followed by the Municipal Intermediate Day School (subsequently the Secondary School for Boys and then the Grammar School) in 1900. The Secondary School for Girls came later.

Amazingly, the side along Oriel Road has survived intact; sadly, the row of buildings along Balliol Road has been lost to war damage and subsequent redevelopment.

The façade of the Town Hall has Lancashire civic coats of arms ranging from Barrow-in-Furness over 100 miles away to next door Liverpool. It is noticeable that Bootle has incorporated the fleur-de-lis of Lancaster into its coat of arms.

Hanging in the council chamber of the Town Hall are the wind-torn flags of Captain 'Johnny' Walker's ships. Through his innovative methods he sank more U-boats during the Battle of the Atlantic than any other British or Allied commander and was instrumental in the Allied victory of the Battle of the Atlantic, one of the most important campaigns of the war. He claimed the sinking of six in one patrol alone. His home, 'Flotilla House', on the corner of Trinity Road and Pembroke Road nearby, displays a plaque recording his decorations: CB and DSO with three bars.

An aerial view of 1921 shows from the left the Town Hall, library, museum, law courts and post office. Round the corner on Balliol Road are the baths and schools. The open ground in the distance is South Park.

28. Promenade Hospital, Southport

The elegant two-storey building in the archive picture was the original hospital built in 1853. Although it bore the date 1806, that was the foundation of the Strangers' Charity that built it. The driving force behind the charity was Thomas Ridgway from Horwich near Bolton, a courser in his spare time; Wilbraham Egerton of Tatton (Park) in Cheshire was one of the first subscribers. Three local ladies were actively involved and medical attention was given by Dr Miles Barton (who had christened Southport at the South Port Hotel) and was a keen advocate of sea bathing. Subscribers to the charity had the right to nominate one 'sick, poor stranger' who would receive money to board for three weeks in Southport. In 1823 an administrative building called the Dispensary was completed and in 1825 this building was shared by another charity that dispensed medicines to the needy. The Dispensary was sold in 1853 when the new building was completed and additions were made in 1862 when the name Convalescent Hospital was adopted. The splendid 'new wing' was opened by the 15th Earl of Derby in 1883. The hospital housed soldiers during both world wars and stayed voluntary until taken over by the National Health Service in 1948.

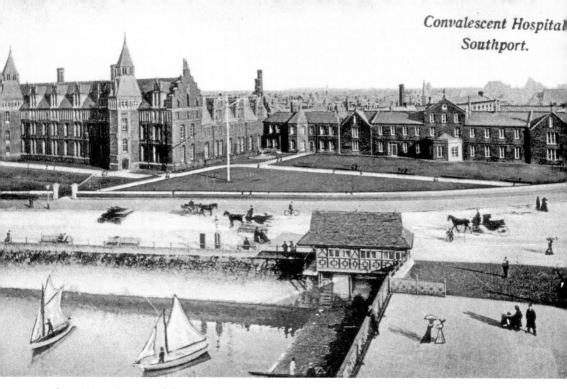

Above: An early view of the Promenade Hospital. The original buildings are on the right and the 'new wing' on the left. The little building in the foreground served the boating lake and was for many years known as the smallest pub in England: 'The Lakeside Inn'.

Below: Marine Gate Mansions.

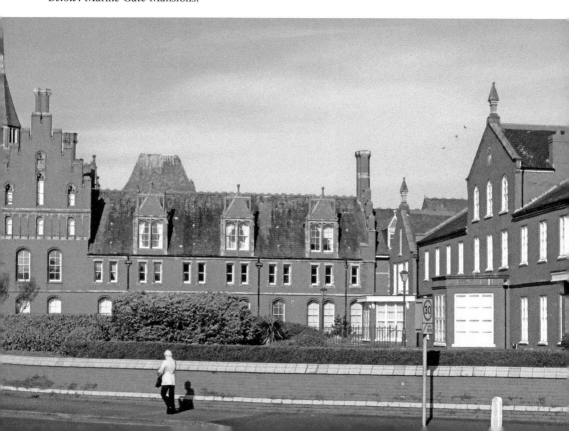

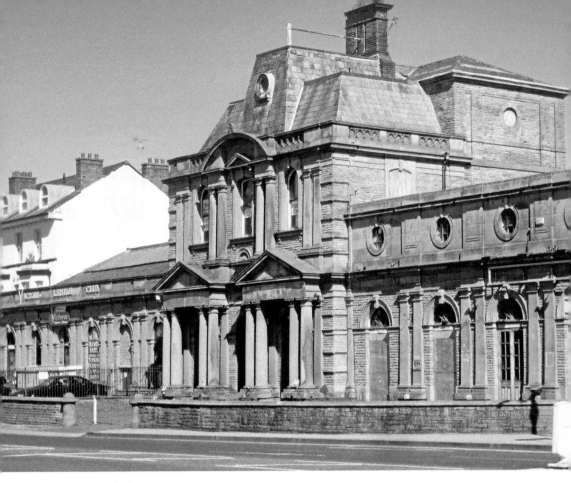

Victoria Baths.

It then treated acute medical conditions and spinal and orthopedic injuries until it closed in 1990. Its work was taken over by the Southport District General Hospital, opened by Prince Charles in 1988, and the Southport General Infirmary. Today this building has been converted into luxury apartments known as the Marine Gate Mansions.

Just down the Promenade is another grand healthcare building of the period: the Victoria Baths, opened in 1839 and remodelled around 1870. At present it encompasses a bar, disused nightclub and Victoria Leisure offering fitness and leisure facilities including modern swimming pools. Unlike many other healthcare buildings, it is still used for its original purpose but there are plans to turn it into a luxury hotel.

29. Lord Street Station, Southport

The striking red-brick façade and imposing clock tower of Lord Street station in Southport command attention to this day. A plaque on the tower tells us that it was opened in 1884 as the terminus of the SCLER (Southport Cheshire Lines Extension Railway). It was perfectly situated within easy reach of the beach, shops and major hotels. The grand design complemented the magnificent attractions of the Winter Gardens entertainment complex next door. It had been a fight for the promoters of the

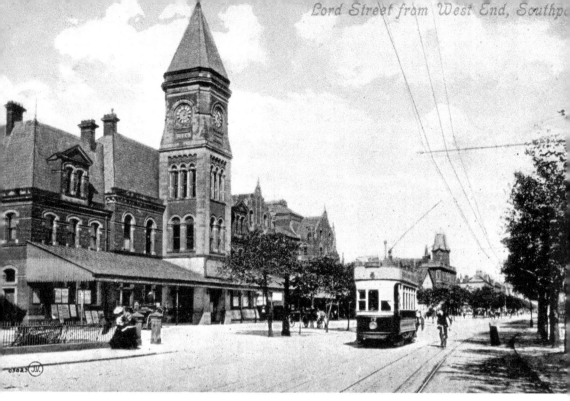

Above: Lord Street Station from the west. The Opera House tower is in the distance.

Below: Lord Street looking west from Cambridge Hall tower many years ago. From left to right in the distance as indicated at the top of the postcard: Birkdale Palace Hotel, Lord Street station, the Opera House, the Winter Gardens and the Royal Hotel, below which can be seen the tower of the Clifton Hotel. Note the gardens originally stretching down from the houses to the street.

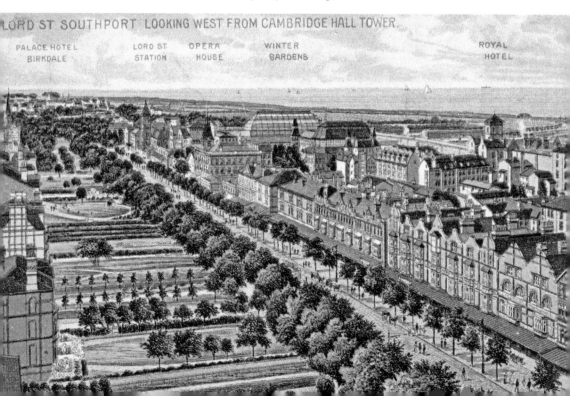

LORD ST SOUTHPORT LOOKING WEST FROM CAMBRIDGE HALL TOWER.

| PALACE HOTEL | LORD ST. | OPERA | WINTER | ROYAL |
| BIRKDALE | STATION | HOUSE | GARDENS | HOTEL |

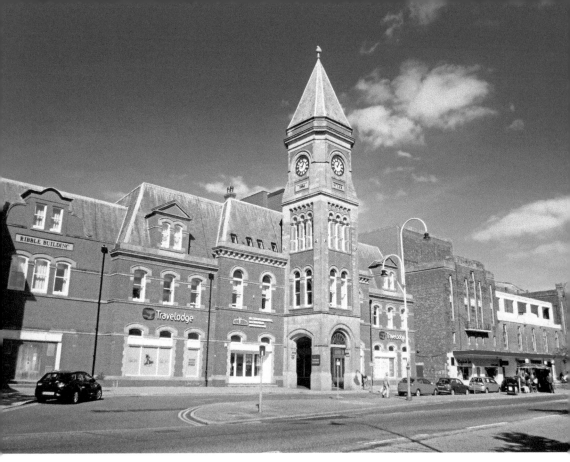

Lord Street station in 1952 looking west.

line to get so far. Originally the line stopped at Birkdale by the Palace Hotel, reputedly built the wrong way round, its entrance away from the coast, with the result that the architect committed suicide (in fact, he died of TB). However, the Cheshire Lines Extension from Birkdale to Lord Street was supported both by the Winter Gardens in the hope of increased patronage and by the Town Council for the protection the railway embankment gave as it made its way round the coast. Victoria Park, the site of the Flower Show, was formed from the land enclosed. Although popular with excursionists, its commuter connections were poor in comparison with the Lancashire & Yorkshire Railway and its terminus on Chapel Street. The 'Lanky' could boast city centre direct connections with Preston, Manchester and Liverpool while the Cheshire Lines served only the suburbs of Liverpool; its circuitous route via Aintree, West Derby and Garston to Liverpool Central was nearly twice the distance of its rival's electrified line to Liverpool Exchange. The closure of the line to Lord Street in 1952 preceded the Beeching cuts and for a while it became the station of the Ribble Bus Co. For a time the approach lines were utilised by a model village incorporating a splendid model railway until more powerful interests took over with a supermarket – the fate of so many disused railway stations – and Travel Lodge predominating.

 The line still maintains its function of bringing visitors in to Southport as it has been converted into a road, which is the best way to approach Southport from Liverpool for those wishing to enjoy the modern attractions of the amusement park.

3c. Albany Buildings, Southport

Albany Buildings is the first and centrepiece of the finest block of buildings in Southport. It stretches along Lord Street from the Wayfarers Arcade opposite the Town Hall to the former National Provincial Bank on the corner of London Square. The buildings epitomise the grand commercial architecture of Southport, reflected in a variety of styles from late Victorian through Edwardian to the early interwar years.

Dating from 1884, Albany Buildings is framed by two outer bays crowned by Tudor-Elizabethan half-timbered gables. Unfortunately, its former perfect symmetry and appearance has been spoilt by later alterations. The original covered ornate balcony on the right has been cut back and opened up on the left (trouble with the roof?). Underneath, the encaustic tiled classical pillars flanking the windows with Gothic overarches are unchanged but below those, one of the beautiful oriel windows has been destroyed. Its replacement, and the shop frontages below, jar not just with each other but with the whole of the rest of the building. However, we have to be thankful that so much has survived intact.

The building to its right, in architectural contrast, has Roman arch windows with elaborate keystones and an oriel window. There are decorative half columns to either side of the main design and classical columns supporting a mock balustrade. Next along, separated by an alleyway – the only break in the otherwise tightly packed and uninterrupted array – is the comparatively restrained polished red granite of the former Martin's Bank

Albany Buildings with its four bays is in the centre; on the left, the Midland Bank (deserving a chapter to itself next) and far right, on the corner, the National Westminster (formerly National Provincial) Bank.

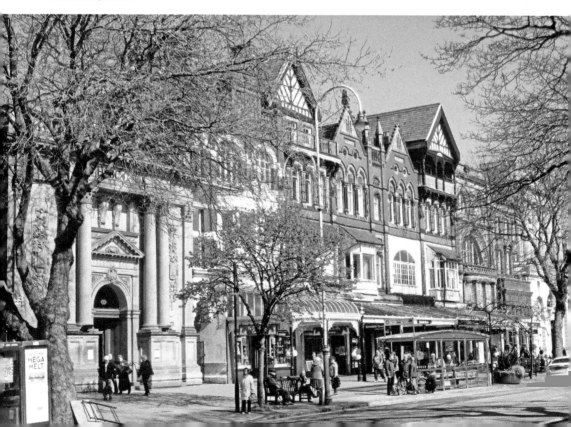

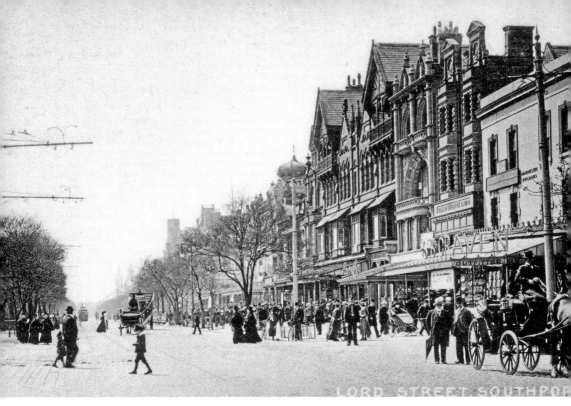

Centre right is the original unspoilt Albany Buildings. The two buildings on the right were subsequently replaced by the Martins and National Provincial Banks. To the left of Albany Buildings the feast of architectural variety stretches into the distance beyond the Midland Bank past the Islamic keyhole windows and cupolas of Nos 319–25 Lord Street to the tower of the Scarisbrick Hotel in the distance.

with Georgian-style windows. In contrast again, the white Portland stone of the former National Provincial Bank (now Waterstones) stands on the corner.

31. Midland Bank, Southport

Britannia crowns this temple of banking, proudly and patriotically wielding a trident with an overflowing cornucopia signifying plenty at her side. The Preston Bank was the first to open in Southport in 1857 and was replaced by this building in sandstone and granite in 1888–89. It has been given the accolade of Grade II* listing, the oldest of three in Southport, and is a fitting climax to the 1880s boom in Southport of building in the classical style.

Underneath the statue of Britannia, resting on top of the triangular pediment, is a shell with interior floral decoration, made steady by volutes. Balustrades with beautifully shaped supporting columns fancifully bear urns embellished with lions' heads, handles, conical lids and elaborately gadrooned rims. The pediment sports the three lions of England. The names of the successor banks (Midland and HSBC) used to appear on the architrave below, which rests on beautifully crafted columns in Corinthian style. A pair of these, in the round, frame the doorway and one at each corner are squared off as pilasters. In between the columns is sculptural decoration. On the left, the old Southport crest and shield is represented with an open lifeboat, later changed inappropriately by the Royal College of

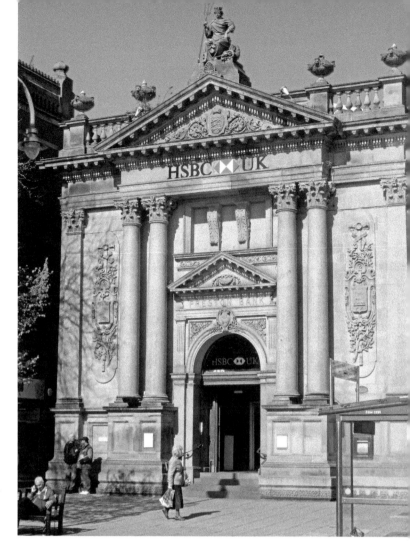

The Midland Bank, next to the Albany Buildings, is designed in the Corinthian order of ancient Greek architecture (acanthus leaf decoration at the top of columns).

The District Bank at the end of the Albany Buildings block, next to the Scarisbick Hotel, is designed in the Ionic order (scrolls at top of columns).

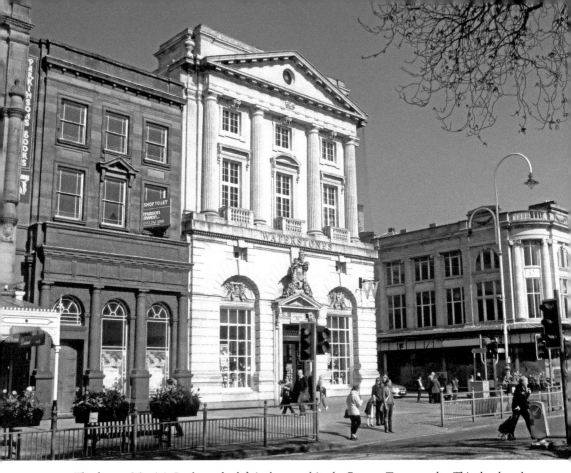

The former Martin's Bank on the left is decorated in the Roman Tuscan order. This developed from the Greek Doric as on the plain tops of the columns adorning the National Provincial Bank in the centre. Its grand triangular pediment is echoed by the doorway modelled on the Erechtheion temple in Athens and surmounted by a magnificent cartouche. These, together with the Midland Bank, complete examples of all three orders of ancient Greek architecture along this block. On the right of the photo is another example of Ionic columns on the Lloyd's Bank building.

Arms to a stylised medieval merchant ship (as on the Monument). On the right, the Preston town crest and shield depicts a flag and lamb, the emblem of St Wilfrid, the patron saint of Preston. It is emblazoned with P(rinceps) P(acis), that is 'Prince of Peace' (Preston's motto). The ornate pedimented doorway reflects the overall design above.

Outside, imaginary windows are recessed in stone but inside light streams down through a coloured glass dome onto deep-red marble Corinthian columns whose magnificent splendour cannot be illustrated for security reasons.

32. Christ Church, Waterloo

Outwardly, the scene has hardly changed in a century but Christ Church has experienced great change inside. The original church, the first in the new township and modelled on St Thomas's in Seaforth, was built in 1840. Owing to the ravages of ivy, it was rebuilt on a grand scale in the 1890s and became a landmark for sailors returning to Liverpool, but a

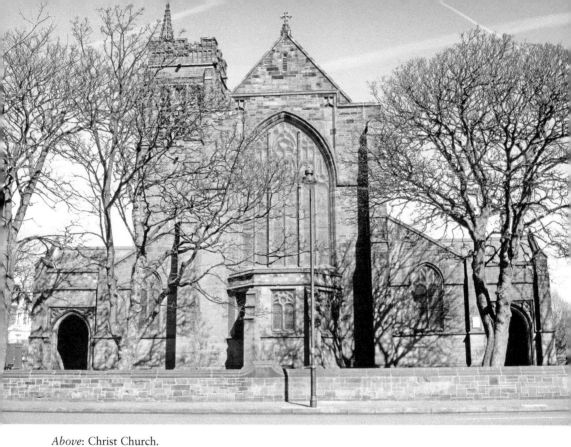

Above: Christ Church.

Below: Potter's Barn.

dwindling congregation and the increasing cost of maintenance led to its deconsecration. The Friends of Christchurch resurrected the interior of the Grade II* listed building (the only one in the area) and established it as a centre for the community with the first event held in 1999.

Near Christ Church on the borders of Waterloo and Seaforth there is a poignant reminder of the battle. William Potter conceived a plan to build a grand house on his land in 1841 with the entrance and stables modelled on the farmhouse La Haye Sante, which played a key role in the battle. But his business interests failed and only the entrance and stables were finished. These were affectionately dubbed Potter's Barn and the initials 'WP' over the entrance preserve his memory. The surrounding land has been converted into a public park.

33. Derby Park Bandstand, Bootle

The bandstand is the focal point of the park. As you enter from the north it is immediately spotted across the bridge that used to cross the lake before it was drained. But it is best approached from the main south-west entrance, which is guarded by the impressive lodge, former home of the head gardener. Then, as you turn onto the axis of the main south/north path, the top of the bandstand is glimpsed, tantalisingly. Gradually it comes into full view until a complete impression is felt from the top of the steps that connect

The bandstand in Derby Park. The bridge parapet is to the left of the bandstand and St Monica's Church can be seen behind the trees.

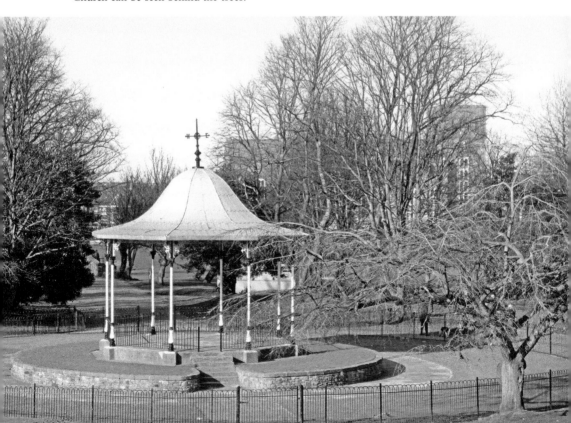

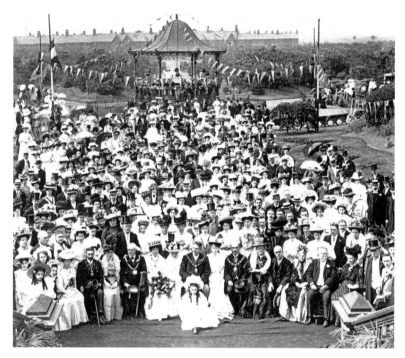

Above: An (Edwardian?) mayoral occasion by the bandstand in Derby Park.

Below: Until the late 1960s there were a series of bandstands in front of Southport Town Hall. Pictured is an early one with an enclosure that the public would pay to enter and then take a seat to listen to the band. At night the illuminated bandstand, fairy lights in the trees and elaborate fountains lit by electricity pulled in the crowds. The present bandstand on a different, inferior site was designed by local architect Martin Perry and funded by Marks & Spencer's to celebrate the centenary of the opening of their first stall in Leeds in 1884.

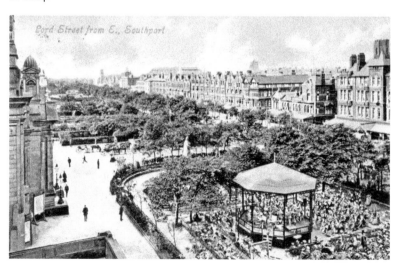

the upper and lower levels of the park. This was the ideal venue for a big ceremonial occasion while the band played in accompaniment. At the end of the First World War the mayor received the widows, relatives and friends of the fallen. On a happier note, the mayor and mayoress staged a gala to celebrate the Coronation of George V and Queen Mary in 1911.

The communal feeling and civic pride was enhanced by a statue positioned prominently to the right of the steps and overlooking the whole area: a memorial 30 feet high with symbolic figures. Funded by public subscription, it is dedicated to William Poulsom, twice mayor, 1880–82, and his wife Mary. As stated on the plaque by the statue, they were 'fiercely proud' of Bootle and 'worked tirelessly and selflessly for the less fortunate people of Bootle'. He was the largest employer in Bootle, instigator of the Bootle police force and chairman of the Borough Hospital. She managed the 'People's Penny Concerts' for twenty-one years. On top of the memorial 'citizenship' holds the charter of Bootle and extends her other hand inviting fellowship. The figures round the base symbolise industry, integrity, benevolence and patriotism. His epitaph reads 'Write me as one who loves his fellow men'.

Lord Derby presented the 22-acre park and beautifully ornate gates to the citizens of Bootle in 1895. The lake and its environs were a playground for the young. At weekends the paths would be a promenade for people to meet and talk. Summer houses provided shade or shelter according to season. Other recreational enthusiasms were satisfied by an aviary, conservatories, greenhouses and a bowling green. It was, and still is, an oasis in a desert of bricks and tarmac.

34. Wayfarers Arcade, Southport

The Wayfarers Arcade, opened in 1898, was originally named Leyland Arcade (after the Liberal MP of the time) and in the 1960s the Burton Arcade. The approach from Lord Street is narrow because the value of the frontage to Lord Street was considered too great to use up with full-fronted access. However, the splendid cast-iron entrance canopy, supplied by Macfarlane's of Glasgow, helps to make up for the narrowness of the way through to the arcade. At the far end beyond the splendour of the widened-out double-height conservatory is a grand staircase and then, considering it opens onto a narrow backstreet, an over the top entrance. This is explained by the original concept, which was to make Leyland Arcade a new way through to the Promenade, of which there are few from Lord Street. This plan was scuppered by development on the Promenade, but the grand rear entrance remains.

There was a three-piece orchestra here between 1950 and 1959 led by Arthur Jacobson, pop recording star of 1928–33, dancing violinist and conductor of palm court orchestras. Previously he had conducted the municipal dance orchestra at the Floral Hall on the Promenade and also the band in Lord Street bandstand between 1935 and 1949.

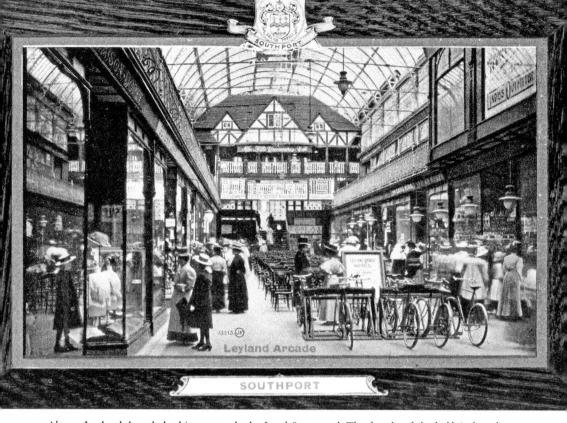

Above: Leyland Arcade looking towards the Lord Street end. The façade of the half-timbered and balconied house has now been removed. The postcard incorporates Southport's coat of arms with the motto *'salus populi'* ('the health of the people').

Below left: Wayfarers Arcade entrance.

Below right: Wayfarers Arcade looking towards the West Street end with a statue of Red Rum and the corner of a modern sculpture, *Botanic Sunshine*, by Stacey Murray.

35. Linacre Mission, Litherland

Originating in 1898 in a two-up two-down house, the first Linacre Wesleyan Mission was built in 1900 to house a congregation of 500. Their work prospered so much that in 1905 a new one was built in front of the existing building to accommodate a congregation of 1,200. New Sunday school premises were opened in 1914 with a fully equipped gym and special rooms for the uniformed organisations and various other groups. In the 1920s Linacre had a Sunday school of 3,000 children, which met at 3 p.m. The Children's Service and the Evening Service (in the Mission Hall) both started at 6.30 p.m. and were filled to capacity.

The site opposite, now occupied by the Hornby flats, used to be the site of a Bryant and May Matchworks factory. In the garden in front of the flats stands a representation of a flaming match with the following inscription: 'The Matchworks factory that stood on this site was opened by the American Diamond Match company and at one time had a continuous matchmaking machine that could produce 600,000 matches per hour. Bryant and May the UK matchmaker bought the goodwill of the factory in 1905. The Matchworks was one of the main employers in the area for over forty years until it was destroyed in the May blitz of 1941.'

Linacre Mission.

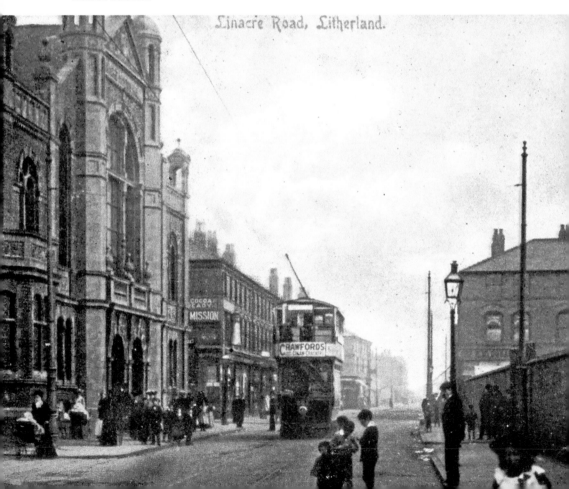

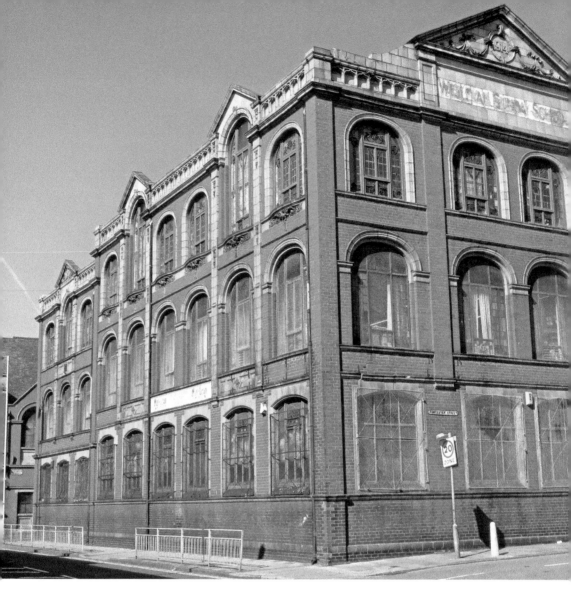

Linacre Mission School.

36. Tramway Depot, Blowick, Southport

This imposing depot was built to house the first electric trams introduced in 1900 (before that horse trams had operated from 1873). Although the building has been disfigured and poorly maintained, the wealth of elaborate decoration on its façade shines out as illustrated in the setting sun. Mock archways and windows (over forty of them) are peppered with make-believe keystones, more than would have been required if they had been real. The larger windows are divided up by mock mullions and the arches over the two side entrances needlessly surmount concrete beams, which are in fact supporting them. There is a rich medley of styles: Romanesque in the shape of the windows; Gothic in the colonettes (slender columns) with tapered bases culminating

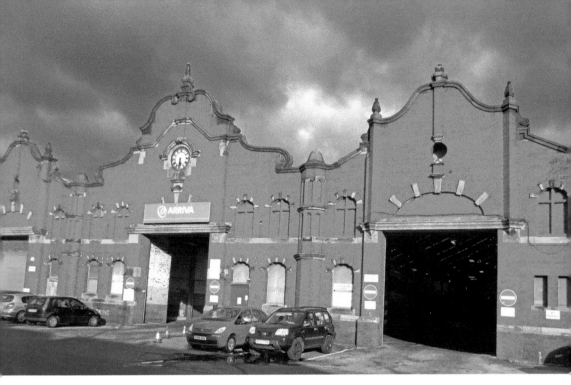

Above: Tramway Depot on Canning Road in Blowick.

Below: A tram at the other end of the network is pictured passing Birkdale Town Hall, demolished in 1971.

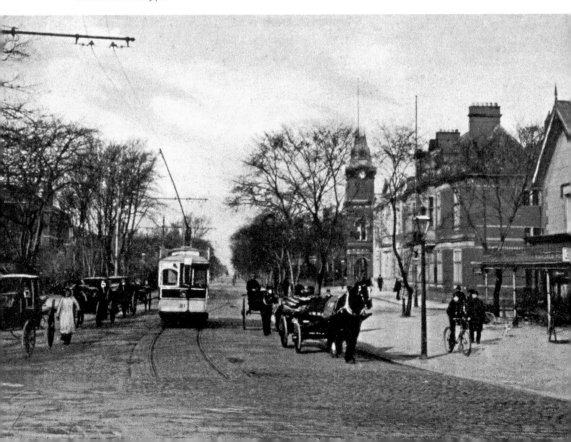

in pointed finials at rooftop level; Dutch in the shape of the gables and the caps to the octagonal towers; and, to crown it all, classical in the scroll of the Ionic Greek order at the highest centre point over the clock. Above use of stone unifies the whole; over all is a coping extending the full width; underneath a line divides the two make-believe storeys; and the clock is decorated with stone around and above. Is it an anchor underneath the Arriva sign? The exuberance and pride exhibited in this façade contrast pointedly with both the straight, functional extension of 1932 to accommodate buses just before the closure of the tramway system and also the brutalist corrugated-iron extension of the 1960s.

Guidebooks boasted that Southport had probably a greater length of tramway – in proportion to population – than any other town in the United Kingdom. The network stretched from the Botanic Gardens to Birkdale but was closed at the end of 1934. There were also trams in Bootle run by the Liverpool Corporation and, from 1900 to 1925, between Seaforth and Crosby, run by the Liverpool Overhead Railway.

37. Carnegie Library, Crosby

Andrew Carnegie was born in Dunfermline in 1835 in a weaver's cottage. The family, in poverty, emigrated to the United States in 1848. Carnegie made his fortune through manufacturing steel helped by the booming economy, especially in the expansion of railroads. He gave away his wealth, equivalent to tens of billions of pounds, largely to the work of education in the broadest sense.

He defrayed the cost of 650 libraries throughout Britain with the maintenance/running costs guaranteed by the local authorities. There were proportionately more in Scotland where he was born but in Liverpool alone he funded the buildings for ten libraries. At the opening of the Crosby Carnegie in 1905, the style was described in the *Crosby Herald* as 'free Renaissance, influenced by English ideas up to date'. It was built in a common design of brick, with stone facings, in the late Victorian and Edwardian fashion that characterised official buildings and banks.

Carnegie libraries pioneered free access to books, thus encouraging browsing, and this is reflected in the accommodation provided in Crosby. Besides the lending and reference libraries for over 13,000 volumes, with news and magazine rooms and separate areas for the boys and ladies, there were heating and coal cellars in the basement, a repairing room on the first floor and over the vestibule a bookstore accessed by a spiral staircase. Comfort was created by heating throughout and the use of electric fans. In the recess behind the foundation stone newspapers, local reports and coins were placed for future historians.

In 1912, puzzlingly, the Juvenile Department had to be closed due to 'unruly behaviour of the children' with police stationed to keep children from surrounding the gate. However, in later years children were welcomed from local schools until its closure in December 2013, following the cuts occasioned by the financial crisis of 2009. Business was transferred to the main Crosby library only a mile away. Six other similar branch libraries in the borough have been demolished or turned to other purposes.

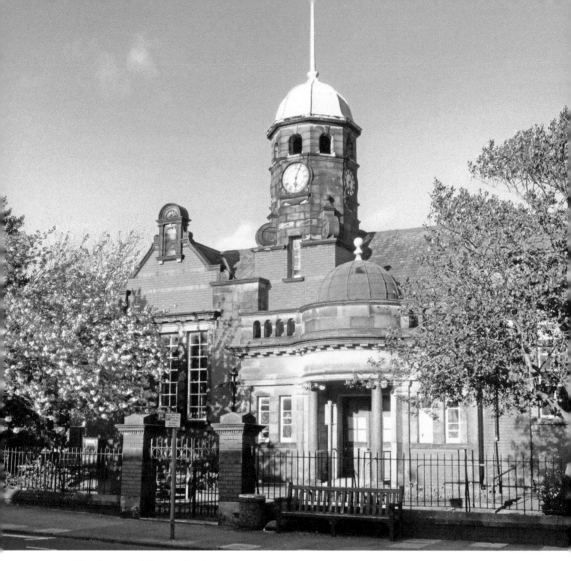

The Carnegie Library, Crosby.

38. Fire Stations, Bootle

The 'old' fire station was opened in 1887. It still serves a useful purpose as the premises of a crane hire firm. However, early in the 1900s, it was deemed to be insufficient to satisfy the needs of the growing borough and the 'new' fire station was built on a grand scale and lavishly equipped. It housed four steam fire engines, two horse-drawn hose tenders and an ambulance with stabling for ten horses and a workshop. There was residential accommodation for ten single and twenty married men. When it closed in 1979 it became a nightclub and is now a trade warehouse.

The land in which the 'new' fire station was built has a fascinating history. Originally it was the corner of the ground of the Bootle Cricket Club and designated for the site of the Town Hall. The cricket club, the second oldest in the Liverpool area, was founded in 1833 and staged two matches against the first Australian cricketers to visit Britain in 1868,

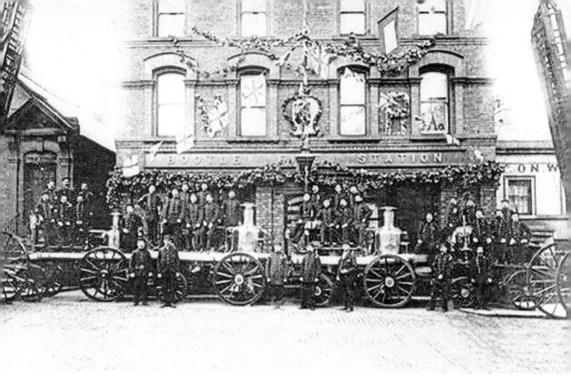

Above: The 'old' fire station in 1897 is bedecked for Queen Victoria's Golden Jubilee.

Below: The 'new' fire station.

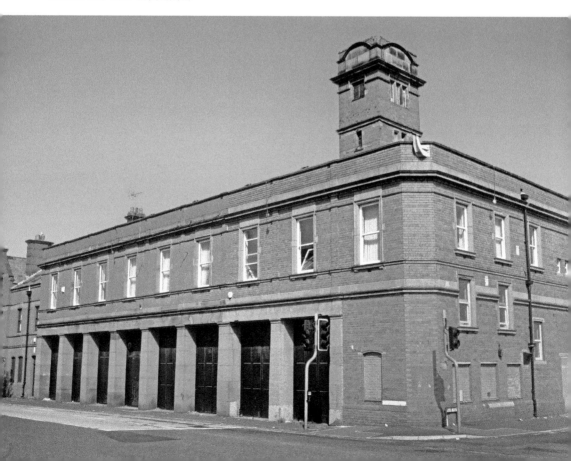

Jesse Hartley's grave.

a team of aboriginals. It moved to South Park to make way for the fire station in 1884 where it still plays.

Opposite the station on the other side of Strand Road was St Mary's Church and its cemetery. The original parish church or 'cathedral' of Bootle, built in 1827, was destroyed by a fire in 1846. The new church held a congregation of 1,500 and, because of its capacity and seniority, was the venue for official services. Enemy bombing in 1941 caused a fire that destroyed the church. A garden of rest was created for the 18,760 people who had been buried in the churchyard, including the grave of Jesse Hartley, who lived in Bootle and engineered the dock walls and seventeen Liverpool docks between 1830 and 1859, including the Albert Dock.

39. Holy Trinity Church, Southport

When Revd Charles Hesketh came in 1835 as rector of St Cuthbert's, Churchtown, he saw there was the need of another church in his parish besides Christ Church to minister to the growing congregation in his parish. His brother, Peter, gave the land and a bazaar raised the funds for the building, a simple structure 58 feet 6 inches long and 45 feet 6 inches wide. It took only four months to build; its successor took eleven years from 1903 to 1914 – probably the shortest and longest periods of church construction in Southport.

The dimensions of the new church (listed II*) are like those of a cathedral, as is its style. The length of the nave measures 157 feet and the width 70 feet in addition to the north transept and the Lady Chapel. The tower is 142 feet high, the tallest in Southport. The architect, Huon Matear, described his church as 'a free treatment of the late Decorated Period'. The tower rises from a red-brick base to elaborate decoration of pinnacles in white stone at the very top (now rebuilt in fibreglass). The clock (just visible to the left of the tower) is set in the tracery of a Gothic arch, which echoes the doorway below. Smaller

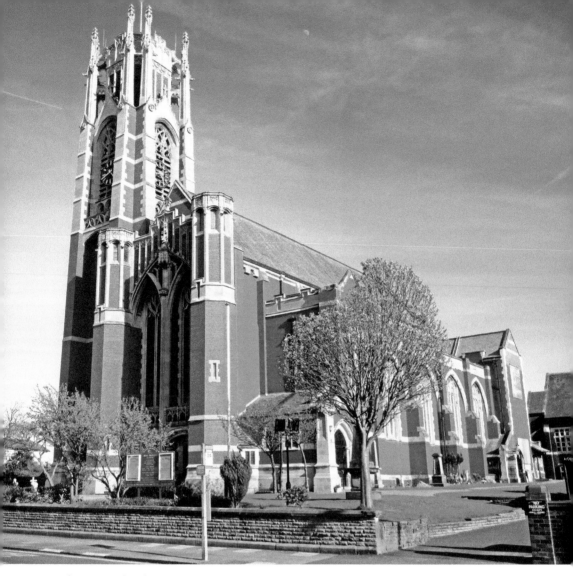

Holy Trinity Church.

octagonal towers link with the main tower and frame the twin pure Gothic arches of the great west window, enhanced by the delicate Gothic sloped windows and the stepped motif leading to the pinnacle of a cross.

40. The Monument, Southport

Unveiled on Remembrance Day in 1923 by the Earl of Derby, the war memorial is a Grade II*- listed building. It is one of the most impressive and moving in the land. At the centre point of the street, nearly a mile long and 90 yards wide, an obelisk 67 feet 6 inches high is flanked by two colonnades enclosing four sacred spaces or temples. Inside are cenotaphs and inscriptions of 1,133 service men who died in the First World War at which wreaths may be laid, and preserved under cover. There are permanent wreaths carved on the side of the

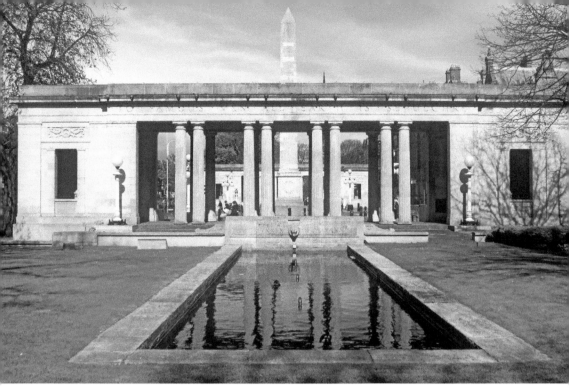

Above: Looking through one side of the Monument to the mirror image on the other side with the obelisk in between. The inscription facing you reads 'To famous men all earth is sepulchre'.

Below: London Square before the Monument. Now, the obelisk stands where the shelter was and one of the colonnades is in the empty space to the right. Note the lack of motor traffic and the tramway branch line to Kew Gardens. On the corner the NatWest (formerly Westminster) Bank is unchanged.

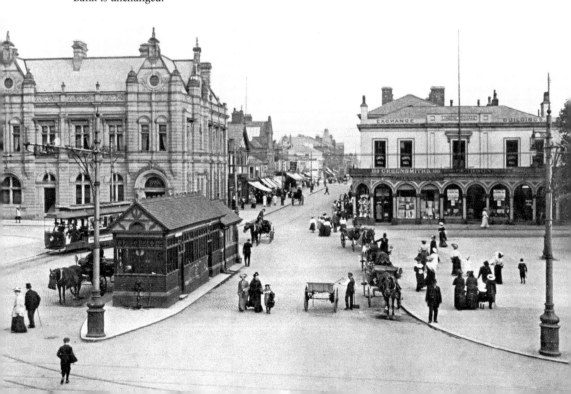

obelisk. The colonnades are supported by Doric columns in pairs, above which is inscribed clearly in large, legible lettering facing each other: 'TELL BRITAIN, YE WHO MARK THIS MONUMENT: FAITHFUL TO HER WE FELL AND REST CONTENT' (adapted from Simonides' epitaph for the Spartans who died at the Battle of Thermopylae). On the other sides are inscribed: 'TO FAMOUS MEN ALL EARTH IS SEPULCHRE' (from Pericles' funeral speech to the Athenians recorded by Thucydides) and 'THEIR PORTION IS WITH THE ETERNAL'. Bas relief carvings on the sides facing Lord Street depict Britannia. On one side a sword hangs from her right wrist and she holds a statuette of Victory in her left hand (modelled on the statue of Athene that used to stand in the temple of the Parthenon on the Acropolis in Athens). On the other side she pays tribute to the dead represented by a military helmet (modelled on an ancient Athenian gravestone). The entrances to the temples are flanked outside by globular lamps representing eternal flames and inside by beautiful Ionic columns.

From the start great care was taken to ensure perfection. A competition for an architect attracted forty-five entries judged by Sir Reginald Bloomfield from London. A local firm, Grayson and Barnish of the Royal Liver building, Liverpool, was chosen. As the specified Portland stone of the highest quality was not available because of high demand at the time for other monuments, the committee waited a year for that and the stonemasons.

41. Garrick Theatre, Southport

In the 1950s there were thirteen cinemas in Southport, nine of them on or near Lord Street. Now there is only one, a newly built multiplex on the seafront. Two cinema buildings on Lord Street do survive from that period but as bingo halls; the Garrick is one of them. It is the descendant of the Southport Opera House opened in 1891 and designed by Frank Matcham, who with his team created more than 200 theatres and variety palaces at the turn

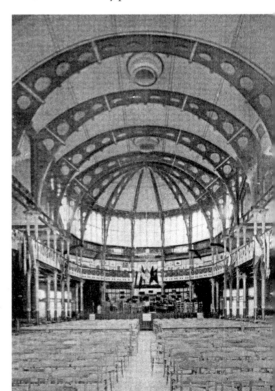

Interior of the first Concert Hall, Winter Gardens, around 1874 – later the Scala.

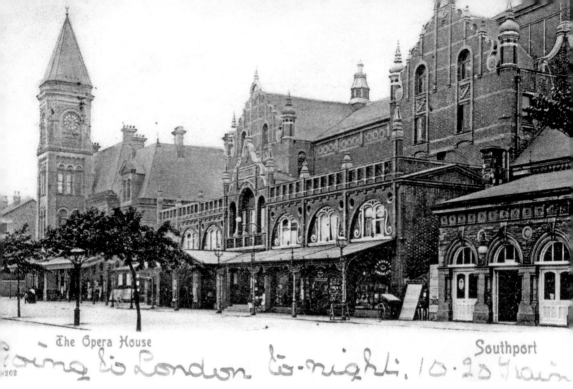

The Opera House

Southport

Above: The Opera House. The message has been put on the front of the postcard as it has not been divided on the back for the message there, which dates it to before 1904. In Edwardian times it was possible to take a sleeping car by train to London.

Below: The Garrick Theatre. Note how the architect has maintained the outline of the Opera House design in a modernist form. The open-air balcony (more clearly seen in the photo of Lord Street station) was not a success because of the vagaries of the weather. The fine lines of its original modernist style have been disfigured by later occupants.

of the century. The 1,492-seat Opera House was part of the Winter Gardens entertainment complex created in 1874 between Lord Street and the Promenade. The site encompassed a grand terrace on the Promenade side, a Crystal Palace-style conservatory stated to be the largest in England, a Promenade Hall and the Pavilion Theatre seating 2,500.

When the Opera House burnt down in 1929, George Tonge was engaged to build a new one. He was later to build the Grand Cinema on Lord Street, still surviving as a bingo club and casino. Replacing the Opera House, the Garrick was one of his finest designs on a grand scale. Seating 1,600, it was a brave attempt to compete with the rise of 'talking' films, not least the 1,200 seat Scala next door. It boasted a stage to accommodate big productions with the latest lighting devices and scene shifting mechanisms. A spacious foyer was decorated in Egyptian style and a broad thickly carpeted staircase led up to the circle lounge. For twenty-five years it produced every form of live entertainment from acrobats to pantomime and opera. In 1957 it was sold to the Essoldo cinema circuit, who converted it to cinema use interspersed with summer shows and Christmas pantomimes interspersed. When, in competition with other leading cinemas, film attendances fell during the turn of the decade, the name was changed to Essoldo, and stage shows and then bingo were introduced. Lucky Seven Bingo took over in the 1970s and in 1984 the former theatre became a Top Rank bingo club.

42. Royal Birkdale Golf Club

The Birkdale Golf Club was founded in 1889, but it was not the first in Sefton. That honour belongs to the West Lancashire Golf Club, the ninth oldest in the country, dating from 1873. The stretch of sand hills along the coast was ideal for links courses and the Liverpool, Crosby & Southport Railway played a large part in their growth. Golf courses were an attraction in promoting high-class residential suburbs built alongside the railway, which thus facilitated commuting to work as well as travelling to and from the golf courses. The West Lancs was followed by the Formby Golf Club in 1884 and the Southport (Hesketh) Club in 1885.

The first clubhouse at Birkdale, constructed in 1897, had to be dismantled in 1904 when it was discovered it had been built outside the limits of the land leased from the Weld Blundells. A former fever hospital in Ormskirk was hastily and cheaply commandeered

Royal Birkdale Golf Club clubhouse in the 1950s or '60s. British Open or Ryder Cup?

The Hesketh Golf Club,
Cambridge Rd., Southport.

MEMBERS' FEES.

	£ s. d.
Resident Members in Borough of Southport—	
Entrance Fee	8 8 0
Subscription	2 10 0
Resident Subscribers'	
Subscription	2 10 0
Country Members resident within 10 miles radius—	
Entrance Fee	8 0 0
Subscription	2 7 6
Country Subscribers'	
Subscription	2 5 0
Visiting Members resident beyond 10 miles radius—	
Entrance Fee	7 7 0
Subscription	2 2 0
Visiting Subscribers'.	
Subscription	1 11 6

Subscribers are persons having a limited membership. They cannot play on Saturdays and Club Competition days, but pay no Entrance Fee.

	£ s. d.
Lady Resident—Ent. Fee	4 4 0
Sub.	1 7 6
„ Country—Ent. Fee	4 0 0
Sub.	1 5 0
„ Visiting—Ent. Fee	3 3 0
Sub.	1 1 0

Visitors' Ticket—2s. 6d. a day, 7s. 6d. a week. 21s. a month.

An allowance is made for families and to persons residing on the Hesketh Estate, particulars of which can be obtained on application.

Application Forms can be had from the Hon. Secy., Mr. W. O. Matteson, at the Club; or from Mr. G. E. Gregson, Hesketh Estate Office, The Grove, Roe Lane, Southport.

An old advertisement for the Hesketh Golf Club. It offers reduced rates for residents in the Hesketh estate.

to fill the gap. Its successor, built in 1935, was part of an ambitious scheme to remodel the course as a championship venue. It was designed in modernist style and said to resemble 'a ship sailing amid a mountainous sea of sand dunes'. The war denied the club the opportunity of hosting a championship in 1940, but the title 'Royal' was granted in 1951 in recognition of its achievements and status. This was followed by its first Open Championship in 1954 and subsequently held there on nine occasions, in total more than any other English course since then. The Ryder Cup was played there in 1965 and 1969.

Meanwhile, Southport and Ainsdale had been opened in 1906, which hosted the Ryder Cup in 1933 (attended by the Prince of Wales and over 18,000 paying spectators on one day) and again in 1937. Adjacent Hillside, dating from 1913, is a championship links, and has been a regular venue for the Open Championship Final Qualifying each year from 2014. This galaxy of golf courses has recently been joined by Formby Hall Golf Resort and Spa constructed in 1996, offering residential accommodation as well as other health and catering amenities.

43. St Monica's Church, Bootle

Consecrated in 1936, St Monica's Church was designed by the distinguished architect Velarde. It was given the accolade of illustrating the front cover of Pollard's updated edition of the 'Pevsner' architectural guide *Lancashire: Liverpool & the South West*. Pevsner had praised it as an 'epoch-making church for England, though not of course for Europe'. Velarde seems to have taken his inspiration from the German architect Dominikus Bohm, who specialised in designing churches in what could be called the Brick Expressionism style. The three angels on the front were designed by H. Tyson Smith. St Monica's is noted

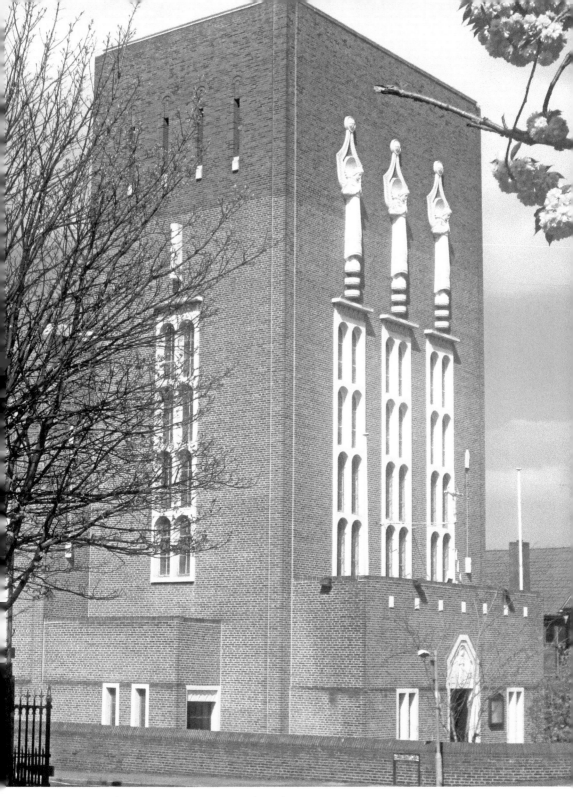

St Monica's façade. The presbytery is on the right.

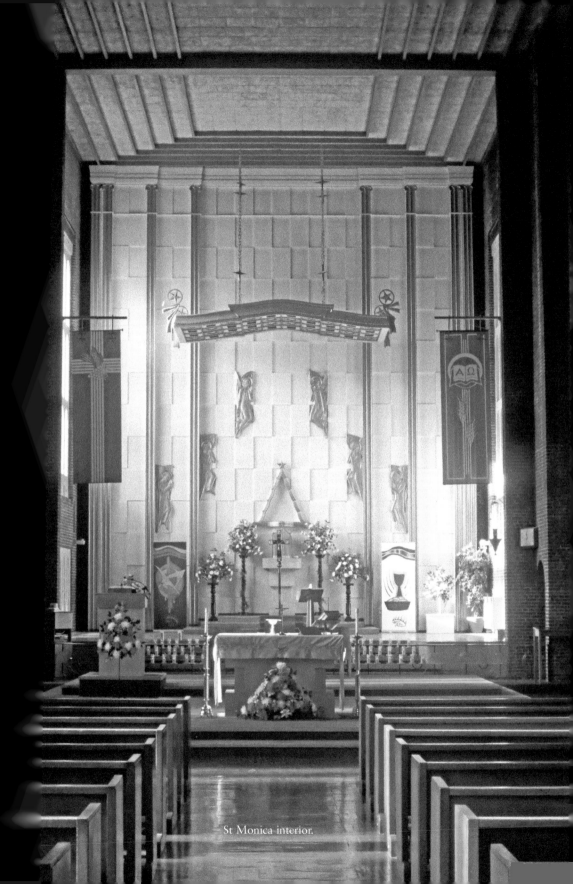

St Monica interior.

particularly for its fine windows, which are a striking feature on the outside and light up the interior magnificently.

The Mission of St Monica was set up in 1922 and a temporary church erected the following year. The first floor of Fernhill Road School (opened in 1926) served as the parish hall and soon became the mecca for dance enthusiasts in the area. Years of fundraising went into the building of the new church in 1936. In 1953 the old church was removed brick by brick to make way for the presbytery.

44. Woodvale Airfield

Woodvale Airfield arrived too late. It was designed for all-weather night fighters for the defence of Liverpool and Bootle during the Blitz of May 1941 but did not become operational until the December. RAF squadrons were then brought up from the south of England to 'rest' (!) for short periods to defend Merseyside. Support units working with all three services also served here, calibrating anti-aircraft guns and towing targets for the Royal Navy. After the war Spitfire, Meteor and Mosquito aircraft were based at the airfield and since 1971 it has operated as a training station for the RAF. It has also been used to host an annual rally featuring model aircraft, classic and vintage cars, and other vehicles.

Woodvale airfield control tower.

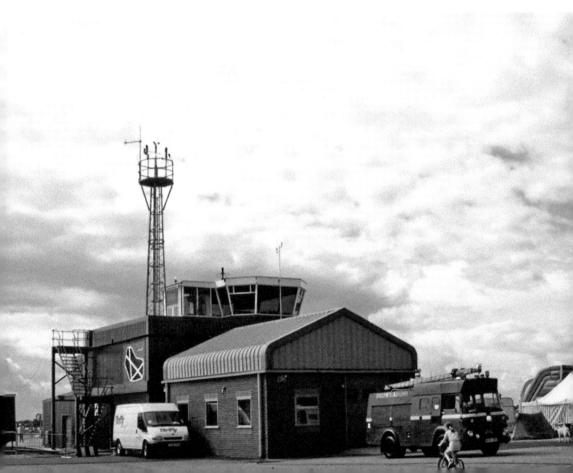

Above: Henry Melly on the Crosby shore.

Below: Merril and Richman commemoration sculpture.

Sefton's sandy shores attracted early aviation pioneers, most notably Henry Melly, who spent his honeymoon learning to fly at the Bleriot School of Aviation in 1910, only seven years since the first flight of the Wright brothers. Settling in Crosby, he immediately set up the Liverpool School of Aviation on the shore between Waterloo and Seaforth with his Bleriot aeroplanes, two hangars and a workshop. The following year he recorded a double first: a complete circuit of Liverpool, and Liverpool to Manchester and return, winning a prize of £1,000 (£100,000 today).

In 1936 Dick Merrill and Harry Richman recorded the first return flight across the Atlantic. After the first leg from New York to London they chose Ainsdale sands as the longest possible runway to take off with their aeroplane heavily laden with fuel for their return trip. A year later the pair returned for another flight carrying films of the coronation for early release in New York. This is commemorated by a stainless steel sculpture of the plane, with a silhouette of the New York skyline, on the shore road roundabout in Ainsdale.

Ainsdale sands had witnessed a speed record on 16 March 1926 when Sir Henry Segrave drove his 4-litre British-made Sunbeam more than 152 mph, seizing the world land speed record from his great rival, Malcolm Campbell. The following year he claimed to be the first man to drive at over 200 mph and set a world record of 203 mph but he died in 1930 on Lake Windermere after breaking the water speed record.

Southport also manufactured planes (and cars) between 1904 and 1945 at the Vulcan works in the suburb of Crossens.

45. Johnsons Cleaners, Bootle

A boarded up building is all that remains in Sefton of a once mighty empire. In its heyday Johnsons Cleaners employed hundreds of staff in a magnificent works opened in 1910 by Lord Derby, and visited by the Prince of Wales in 1921. These were the days when everyone wore a hat and never threw one away. One floor of the works, staffed entirely by women, was a hive of activity devoted to renovating hat wear. Velour, felt and straw hats were

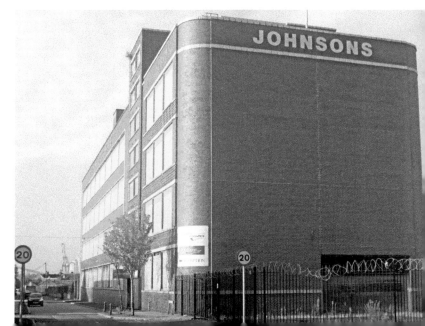

Johnsons Cleaners' Bootle building awaiting redevelopment. The new red cranes of the Liverpool2 development at the Royal Seaforth Container Dock can be seen in the distance to the left.

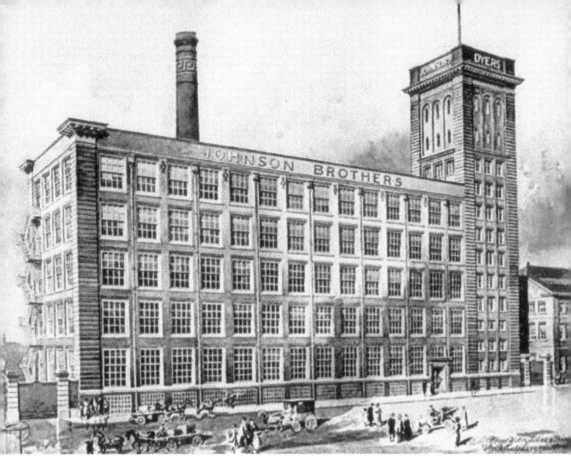

Johnsons works of 1910.

cleaned or dyed and remodelled. They were advertised ('Why buy a new one?') to look and wear like new.

The Johnson Brothers started business in Liverpool as silk dyers in 1817 but the origins of the company can be traced back to 1780. The works of 1910 were badly damaged in the May Blitz of 1941 but the site was restored after the war and reopened in 1957.

The 1960s saw a change in operations from central processing to machinery in branches. Manufacturing operations, such as hats, had changed too. Although the main factory closed in 2003, after a series of takeovers the number of outlets on the high street peaked at 550 in 2006. The following year the company's headquarters were moved from Bootle to Prescot. It has diversified into hire and contract work for large companies and online services. Now less than 10 per cent of profits come from its retail division.

At the time of writing plans had been approved for the conversion of the building to eighty-two apartments with retail premises (a dry cleaners?!) on the ground floor.

46. The Triad, Bootle

Since 1974 the Triad has been a beacon and a focal point for the regeneration of the centre of Bootle devastated after the war. It stands on the edge of the New Strand shopping complex, which was constructed at the point where Strand Road met Stanley Road and

Right: The Triad with the New Strand shopping complex on the left.

Below: Stanley Road as it used to be. The horse-drawn bakery van, parked on the wrong side of the road, belongs to Blackledge's, who boasted over ninety shops in the Liverpool area at the height of their popularity. A procession of vehicles drawn by man and horse approaches on the right.

now obliterates the road from which it takes its name. This involved the compulsory acquisition of 148 shops and 450 dwellings. When completed, New Strand contained 126 shops including a department store, two variety stores and three supermarkets.

Stanley Road runs straight for nearly 2 miles from one end of the borough to the other. It was the backbone of Bootle. On one side was the grid pattern of the civic area, designed in the estate office of the Earl of Derby, and on the other the natural growth of the old village. Parks, balanced in orientation, enhance each end, South Park to the east of the road, North Park to the west. Stanley Road (Liverpool) was grand enough, with over 1,000 premises along its route, but Stanley Road (Bootle), with another thousand, was grander. Magnificently ornate lamp stands emblazoned with the Bootle coat of arms – superior in design and effect to those of Liverpool – stood in the centre of the road. A superb tram service united the two communities and their conjoined 2,000 residences. Now the thoroughfare is restricted and only taxis and buses can travel the full length of the Stanleys.

In Edwardian days, the stretch of Stanley Road now occupied by the New Strand was lined with a bewildering variety of shops on one side of the road only: a tea dealer, ironmonger, bootmakers, dyer and cleaner (Johnsons of course!), hosier, confectioners, milliner, glass dealer, pork butcher, grocers, draper, watchmaker, butcher, furniture dealer, stationer and tobacconist, greengrocers, grocer/provisions, bakers and flour dealer chemists, ladies' outfitter, tripe and fried fish dealer, picture frame maker, hatter, tailor and florist. With many of these you had a choice of premises. How does the New Strand compare?

47. Coastguard Station, Crosby

The coast from Bootle to Southport has always been treacherous for sailors. Liverpool Coastguard station on Hall Road has been at the epicentre of many major maritime incidents stretching from North Wales to the Cumbrian coast and from a helicopter crash to the collapse of a wind farm. Saddest of all was the Morecambe Bay tragedy of February 2004, which claimed the lives of twenty-one cockle pickers. The station was opened in 1982, received a £1 million extension in 2001 and closed recently amid protests at government cuts.

Britain's first lifeboat station was established in Formby sometime before 1777 when it was recorded as in need of repair. A minimum reward of one guinea (£200 today) was paid by the Liverpool Corporation for every human life that was saved. Five of the crew of eight of the Formby lifeboat perished in an attempted rescue in 1836. In 1886 the Southport lifeboat station was involved in one of the greatest such disasters. An iron barque, the *Mexico*, having set sail from Liverpool, was driven on to Ainsdale sands. Fourteen of the crew of the Southport lifeboat *Eliza Fernly* perished in an attempted rescue as did thirteen from the St Anne's boat but a boat from Lytham succeeded in rescuing the *Mexico*'s crew of twelve. A fund for the bereaved closed within a fortnight at a total of £30,000 (£3.5 million today), alleviating their poverty.

A boathouse was first erected for the Formby lifeboat in the early nineteenth century but the station was closed in 1918. The building housed a café for many years until demolition in 1965. Now only a sandstone plinth and some brickwork at the end of Lifeboat Road are a reminder of one of Britain's firsts.

Above: Crosby Lifeguard Station with the sails of a wind farm in the distance. A large wooden marker on the nearby shore is one of an original pair a mile apart for ships to calibrate their speed.

Below: Formby Lifeboat Station showing the penultimate Formby Lifeboat prior to the station being taken over by the RNLI. After that the station was enlarged and given a new front as well as a new lifeboat.

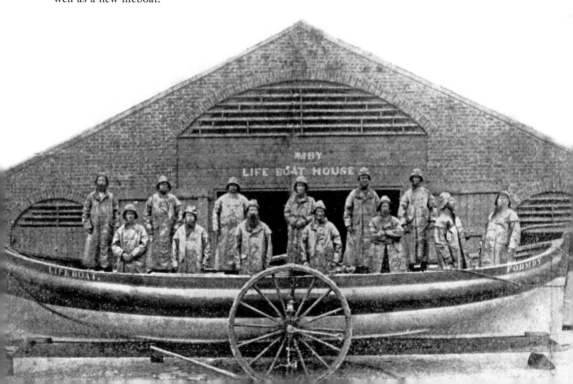

The shore with mile marker and Antony Gormley's Iron Men.

Crosby lifeguard station looks onto one end of Another Place, an installation of one hundred statues of Antony Gormley stretching nearly 2 miles along the coast past Waterloo to Seaforth. They were first set up in 2005 but were saved from being passed on to New York by local enterprise and are there to stay.

48. Aintree Racecourse

The Lord Sefton Stand at Aintree offers a superb view of the start of the 2014 Grand National. Thirty-seven horses started and eighteen finished. In the first Grand National of 1839 seventeen horses started and ten finished. The beautiful, elegant grandstand designed by the Liverpool architect John Foster and dating from 1829 burnt down in 1892. Graceful and decorative, it held 2,000 spectators and incorporated vestibules on the ground floor, a refreshment room on the first floor, a balcony and withdrawing rooms. This was replaced by the County Stand (now the Lord Daresbury Stand) described by Pevsner as a 'large but unremarkable structure' and enhanced by the Queen Mother Stand opened in 1992 and the Princess Royal Stand in 1998. In 2007 two further stands were added in honour of Lord Sefton and the Earl of Derby.

Red Rum (1965–95) was bred in Ireland but his career took off when he was bought by Southport car dealer Ginger McCain. He was trained on the sands at Southport and his galloping through sea water may have proved highly beneficial to his hooves. He achieved an unmatched historic treble when he won the Grand National in 1973

Above: The Lord Sefton stand overlooks the start of the 2014 Grand National.

Below: John Foster Junior's grandstand of 1829.

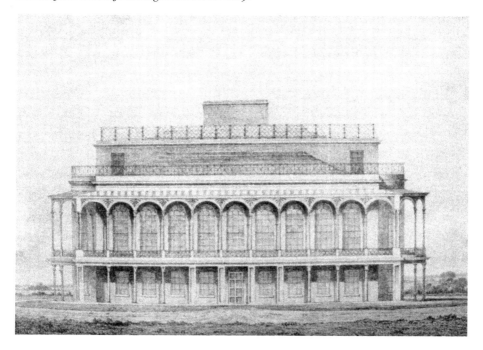

(coming back from 30 lengths behind), 1974 and 1977. He also came second in the two intervening years (1975 and 1976). His jumping ability was renowned, having not fallen in 100 races. Red Rum was prepared for a sixth attempt at the Grand National in 1978, but suffered a hairline fracture the day before the race and was subsequently retired, a national celebrity.

Red Rum.

49. Hugh Baird College, Bootle

In 1892 a technical school, the predecessor of the Bootle Technical School, was opened in the basement of the Free Library and Museum with 807 students (543 of these residing in Bootle). The school ran thirty-seven courses in twenty-six subjects, which expanded by 1897 to include building, home dressmaking, mechanical engineering and iron/steel manufacturing. Today, its successor, Hugh Baird College, with three main buildings on its campus, offers hundreds of courses to more than 7,000 students. In 1974 new buildings were opened by the

Hugh Baird Higher Education Centre L20 building.

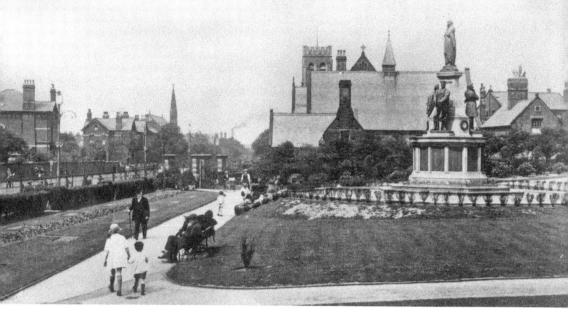

Above: A view taken before the Second World War shows Emmanuel Congregation Church centre right beyond the war memorial. On the left is the spire of the pre-war Welsh Presbyterian Church (destroyed in the war) and in the distance signs of industrial Bootle.

Below: This view taken between 1972 and 1976 shows the post-war commercial development on the Bootle centre. Tower blocks starting from the left are: Hugh Baird College, Daniel House, St Martin's House (the top of Merton House just showing above it), The Triad, Balliol House, St John's House (since demolished and rebuilt) and St Peter's House. The Centenary Garden on the site of Emmanuel Church beyond the war memorial is flourishing. The spire of the Welsh Presbyterian Church, rebuilt after the war, is now is dwarfed and scarcely visible (left of centre) among the modern office blocks. It has now been converted into office accommodation.

chairman of the Further Education Committee and named after him. Hugh Baird had also been mayor and served on all the main committees for many years. It is a measure of Bootle's community spirit that at least ninety streets have been named after councillors and council officials. Over the road from the original college building, the Balliol Centre is the L20 Higher Education Centre opened in 2014. This was the first one purpose built on Merseyside.

Unfortunately it has destroyed a bit of history. The site was originally occupied by Emmanuel Congregational Church, built in 1876 for 750 people. When it burnt down in 1965, the site was transformed into a garden to celebrate the centenary of the borough in 1968. This survived for barely half a century when it succumbed to the dread hand of developers.

50. Seaforth Container Dock Cranes

A row of five gigantic cranes were installed in 2016 as part of the latest £400 million extension to the Liverpool Dock system. Called Liverpool2, it can now accommodate in tidal waters the latest and largest container ships of Post-Panamax dimensions, which is more than the maximum size formerly allowed to traverse the Panama Canal. It can thus accommodate more than 95 per cent of the global container fleet with vessels transporting up to 14,000 containers per ship. The cranes are based at the Royal Seaforth Container Dock, opened by the Princess Royal (then Princess Anne) in 1971 with nearly 2 miles of quay. Seaforth was badly affected by bombing during the war, which started an exodus, and post-war it suffered even more from developers. What precipitated its decline most of all, however, was the opening of the Container Dock. Unfortunately, Princess Way, the road to carry the freight traffic to and from the dock, had the effect of dividing the community in two.

Bootle came into being to protect itself against the incursion of Liverpool housing and its Dock Board. The names of the docks as they advanced northward from Liverpool sound like a roll call of famous people connected with the city and its maritime heritage. On the Bootle foreshore these were Brocklebank, Langton, Alexandra, Hornby and, finally, Gladstone, with more than 3 miles of quays. They were linked by the unique Liverpool Overhead Railway The Gladstone graving dock, designed to accommodate the largest transatlantic liners, was opened in 1913, and the associated wet docks became fully operational in 1927. As a boy, William Gladstone, four times prime minister, lived in the family home in Seaforth, built with the profits of his father's slave trading. It has long since gone, the estate sold for housing, some of it now demolished in turn for the construction of Princess Way.

In spite of its reduced area, the tonnage shipped through the Liverpool's system is greater than ever, most of it in the form of containers through the Seaforth dock, which became a Freeport in 1984. The other working docks now handle *importation* of coal and exportation of *scrap metal*. How times change!

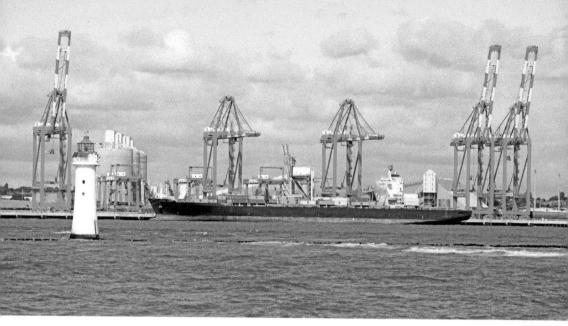

Above: New Liverpool2 cranes at the Royal Seaforth Container Dock with one of the old blue container cranes behind. MSC Koroni is unloading with the New Brighton lighthouse in front.

Below: Gladstone Dock pre-war with the Overhead Railway in the foreground.

Overlooked by one of the older container cranes, the mural on a transit shed at the dock depicts the *Titanic*, the Overhead Railway, seaside scenes before the dock was built, the Five Lamps at Waterloo, the Crosby Mill, and a tram and station on the Seaforth to Crosby tramway.